WILD WEATHER
ON THE PRAIRIES

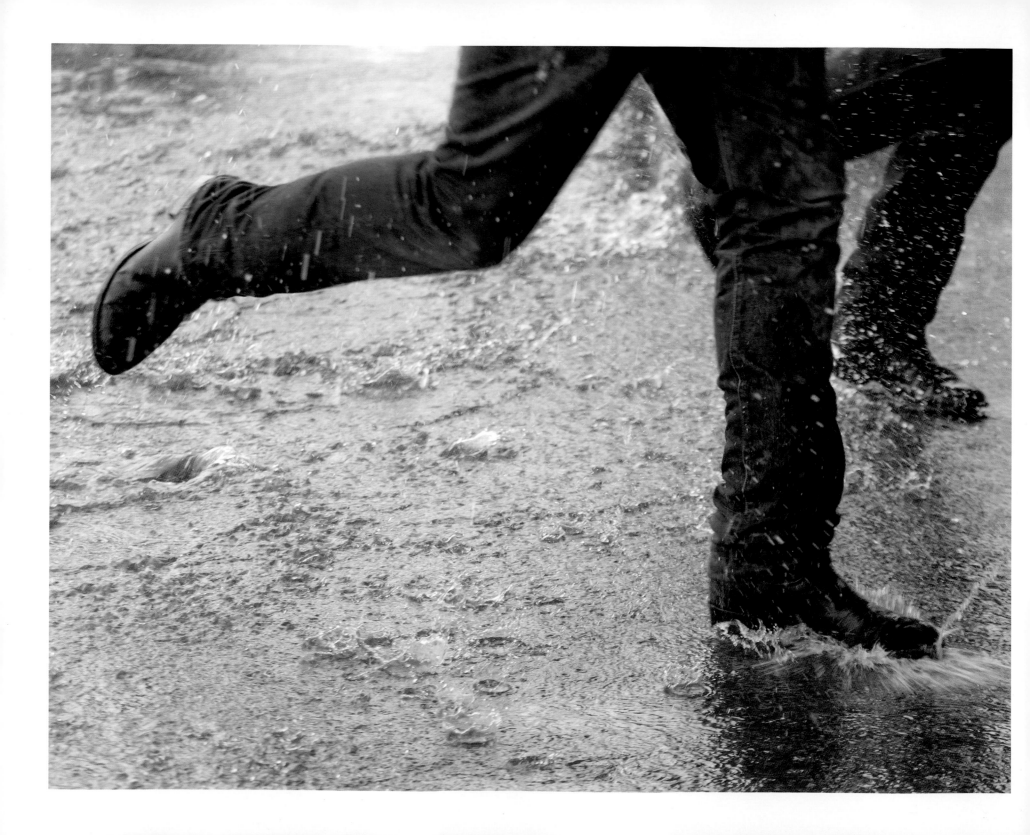

WILD WEATHER
ON THE PRAIRIES

FROM THE **CALGARY HERALD** · **CALGARY SUN** · **EDMONTON JOURNAL** · **EDMONTON SUN**
REGINA LEADER-POST · **SASKATOON STARPHOENIX** · **WINNIPEG SUN**

BY **MONICA ZUROWSKI** WITH **NORMA MARR** AND **KAREN CROSBY**

GREYSTONE BOOKS
Vancouver/Berkeley

Greystone Books Ltd.
www.greystonebooks.com

Cataloguing data available from Library and Archives Canada
ISBN 978-1-77164-316-0 (cloth)
ISBN 978-1-77164-317-7 (epub)

By Monica Zurowski, with Norma Marr and Karen Crosby
Additional collaboration: Girard Hengen, Marlon Marshall,
Mark Hamm, Kevin Engstrom, and Al Charest

Much of the work in this book is based on text and photographs
created by dozens of talented journalists at Postmedia properties
in Alberta, Saskatchewan, and Manitoba.

Editing by Jennifer Croll
Proofreading by Jennifer Stewart
Jacket and interior design by Naomi MacDougall
Printed and bound in China on ancient-forest-friendly paper
by 1010 Printing International Ltd.

We gratefully acknowledge the support of the Canada Council for the Arts,
the British Columbia Arts Council, the Province of British Columbia through
the Book Publishing Tax Credit, and the Government of Canada for our
publishing activities.

CONTENTS

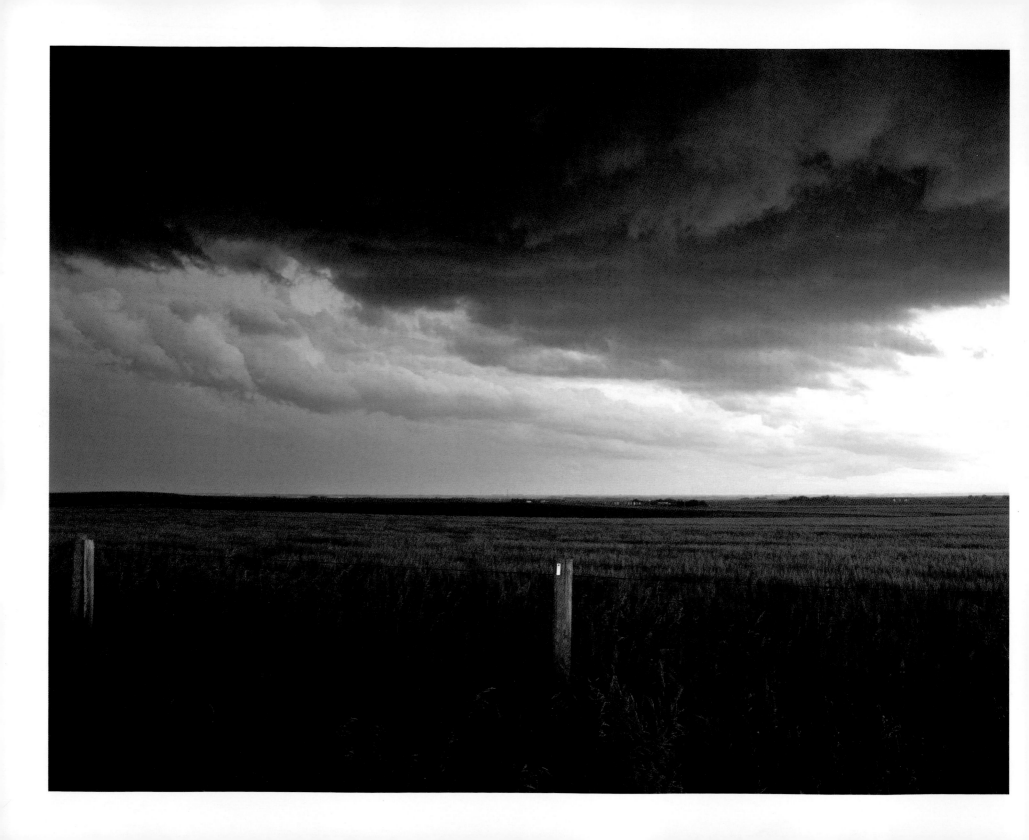

INTRODUCTION

WEATHERING THE STORM— LIFE ON THE PRAIRIES

WOUNDS HEAL, BUT scars remain. Three decades have passed since a tornado ripped through Edmonton, killing twenty-seven people and injuring hundreds more. The city has rebuilt and repaired itself in the years since the 1987 natural disaster. The injured have, mostly, been rehabilitated. But scars persist for many of those who survived the twister, which carved a path of carnage, wrecked homes, and wrenched hearts.

The stories from survivors still resonate as hellish thirty years later. The twister, for example, ripped a three-month-old baby from his mother's arms and hurled him into

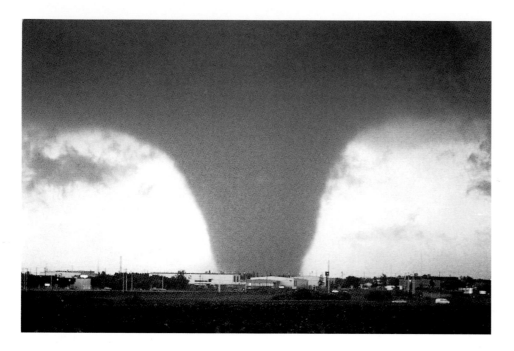

a puddle, fracturing his skull, severing his spine, and leaving him paralyzed. It sucked the roof off a tool shop, collapsed the cement walls, crushed the twenty or so people inside, and indiscriminately took lives. The tornado flattened businesses, tossed cars about like they were toys, smashed homes, and shattered families, none more so than the family of Arlean Reimer.

Because Arlean was running late at work the day of the tornado, she wasn't home when the twister roared through Edmonton's Evergreen Mobile Home Park. Tragically, her husband Marvin, along with their three children—Dianne, thirteen, and eleven-year-old twins Darcy and Dawn—were there. All four perished in the disaster. Their trailer was nearly obliterated. Days later, a large crane hoisted the splintered remains of the Reimer trailer so Arlean could retrieve a few family belongings that remained intact: her

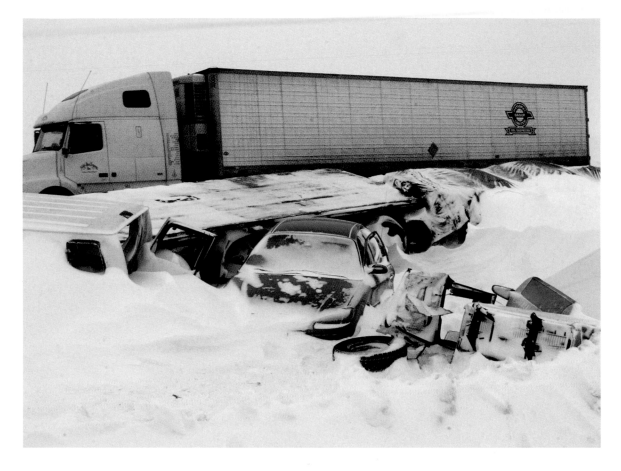

A February 2004 blizzard caused a chain reaction of crashes involving more than forty vehicles near Balgonie, Saskatchewan, 30 kilometres east of Regina. (Roy Antal/*Regina Leader-Post*)

children's Cabbage Patch Kids dolls and her husband's wedding ring, which had been sitting on a dresser awaiting a repair.

The tragedy is a sad chapter in the story of the Edmonton tornado, but it's also a reflection of how weather profoundly impacts the lives of people on the Prairies. It's a region where history and growth are inextricably linked with the unpredictable narrative of the weather.

Weather is the tie that binds us, unites us, and gives us something to discuss around the water cooler. On any given day, we can love it, hate it, or love to hate it. Whatever we think about the weather, one thing is certain—it defines us. Coping with a particularly harsh day, for example, is a badge of honour, worn proudly by those who make their home on the Great Plains, an endless swath of prairie land with open skies and picturesque panoramas.

Some parts of the world possess climates that can best be described as "even." They receive even amounts of rainfall, little variance in temperatures, and predictable amounts of sunshine. It's a different case on the Great Plains, which stretch up through the central United States and into the Prairies of Alberta, Saskatchewan, and Manitoba. The region experiences extreme temperature fluctuations and unexpected weather events several times each year. Many words can be used to describe the weather here—harsh, severe, fickle. Boring, however, isn't one of them.

At times, the weather becomes downright biblical in intensity. Massive floods sweep across the land. Wicked winds uproot trees, structures, and people. Icy snowstorms bury entire communities. Fires roar across grasslands and forests. The events don't signal an apocalyptic end of the world. Rather, they're just part of the wild weather of the Prairies.

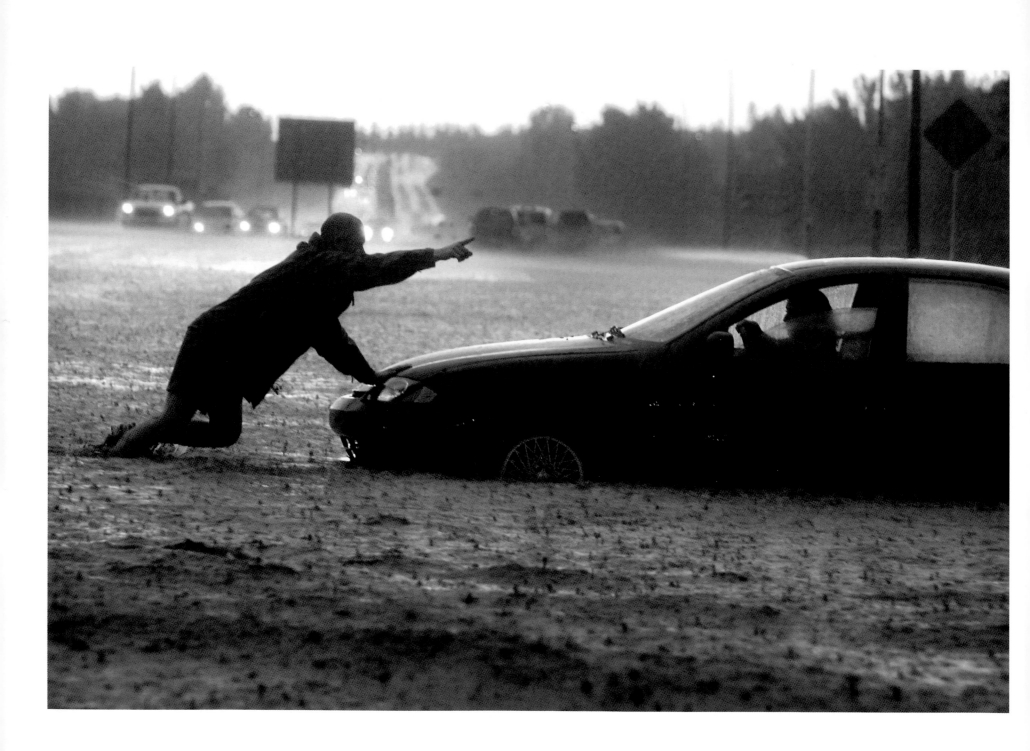

As a result, the four extremes of weather—wind, water, ice, and fire—influence how we work, how we play, how we dress, how we move about, and how we come together as communities. It's been that way for generations. Pioneers moved to the Prairies with dreams as big as the unending blue sky. They found a land where the sun shone and rain fell—a perfect place to plant seeds for crops and new lives.

While the weather often smiled favourably upon these settlers, storm clouds could also loom on the horizon. There were years when Mother Nature would choose to be either overly generous or stingy with rainfall. Rivers could dry up, or flood. Winds could howl. Snow could bring any community to a suffocating halt. Lightning could strike, igniting a blaze.

The climate of the Prairies, which so often nurtured life, could also prove fatal. For those who settled here, protection from the elements was vital. Upon arrival, settlers would need to find or build shelter to protect themselves from biting winds, sizzling sun, or wild wind chill, depending on the season. To not shield oneself could lead to disease, sunburn, or frostbite, and occasionally death.

Settlers depended on the climate to sustain themselves, too. They needed the weather to co-operate and provide just the right mix of moisture and sunshine so they could grow food for themselves and their livestock. The weather often did just that and helped Canada develop a reputation as one of the world's most important grain producers. The first wheat crops sprouted in Manitoba's Red River Colony in 1814. Hogs arrived a few years later. The government quickly realized that farmers would not only help the country's economy grow; they could also assist in protecting land that had been staked as belonging to Canada.

So, for a $10 fee, aspiring farmers received a quarter section of land in the West from the government. Farming became an important component of Canada's cultural and economic identity. As years passed, wheat prices increased and then boomed during the First World War. Agriculture became one of the pillars of the country's wealth and growth.

The weather, however, could sometimes present unexpected obstacles. The 1930s, for example, saw veritable plagues of locusts descend on the Prairies. Dust storms, grasshopper infestations, and crop disease occurred, but farmers' resilience ruled. They experimented with variations of wheat until they found the hardiest. They implemented techniques such as summer fallowing, to allow land to rest and regain moisture every other year. Farmers learned to work through dry weather, wet weather, hailstorms, and a short growing season.

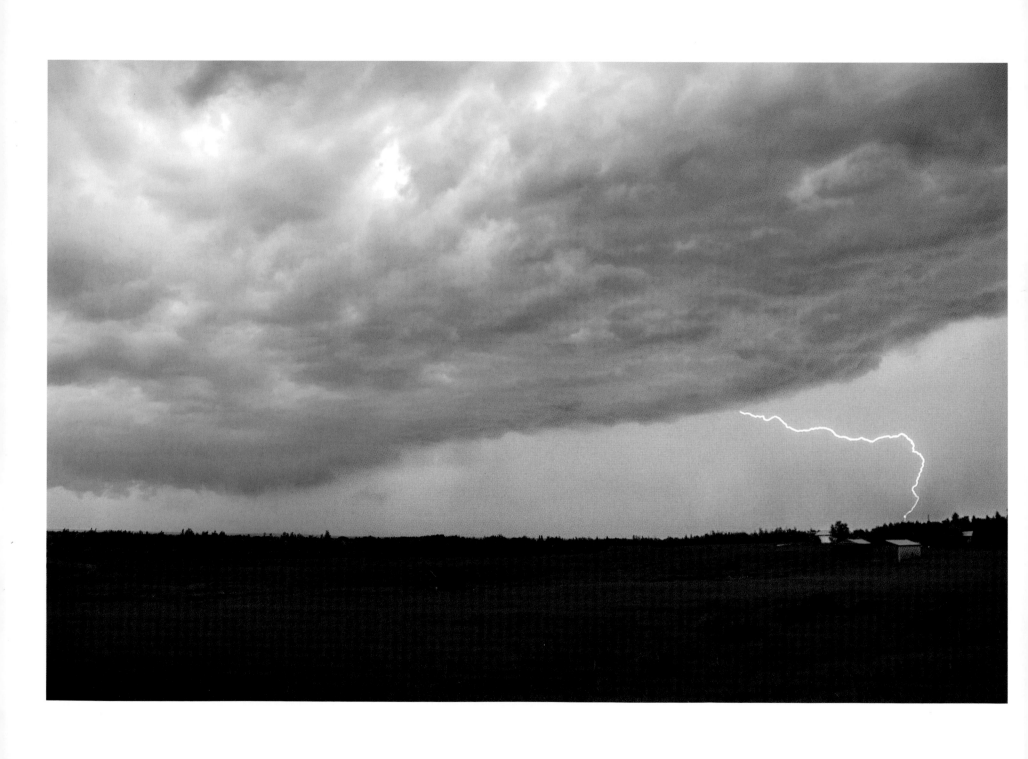

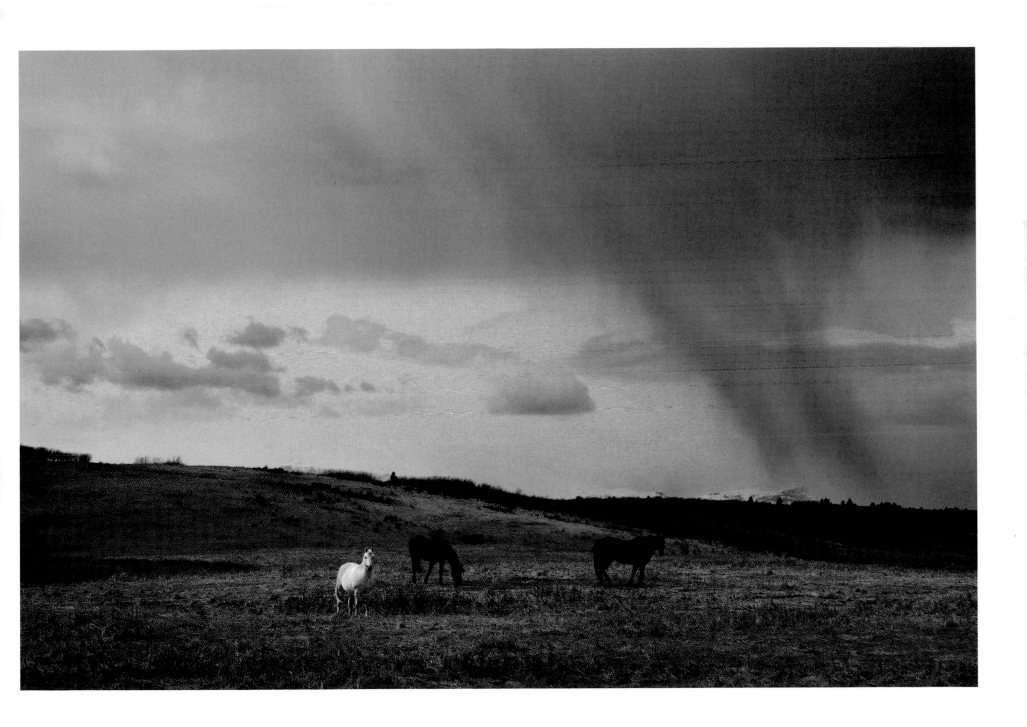

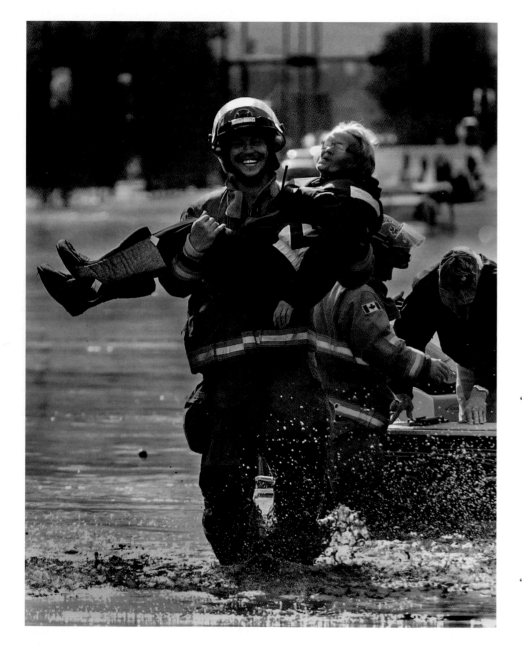

LEFT A firefighter carried a woman to safety in High River, Alberta (55 kilometres south of Calgary), after she became stranded by 2013 floodwaters.
(Lyle Aspinall/*Calgary Sun*)

FACING PAGE Dayne Becker, then thirteen, carried his chihuahua, Teako, through a swamped Yorkton, Saskatchewan, street in 2010.
(Troy Fleece/*Regina Leader-Post*)

They adapted to the weather while creating legends and lore that often centred on the climate. Stories were passed down from generation to generation. Grandparents regaled children with tales of walking to school for miles, through banks of snow, uphill both ways. Physically possible? No. Highly entertaining? Yes. People of the Prairies developed a fascination with the weather—one that continues today.

Over the years, Prairie folks were occasionally criticized for their weather obsession. An American energy expert, working in Lloydminster in the 1940s, told a board of trade meeting that "Canadians suffered from an inferiority complex," according to a *Regina Leader-Post* article on February 3, 1947. "This was demonstrated ... by their tendency to over-stress the cold winter weather." The expert, Art Knight, made the remarks on the same day that the newspaper's front page reported on how Saskatchewan was coping with almost five weeks of continuous blizzards. Ranchers and farmers had lost thousands of cattle and other livestock. Supplies and food in small towns had dwindled to dangerously low levels. Roads were closed everywhere and trains were snowbound for months; "weary railwaymen admitted defeat ... The weather had won." To those dealing with a harsh winter, an inferiority complex seemed to be the least of their problems.

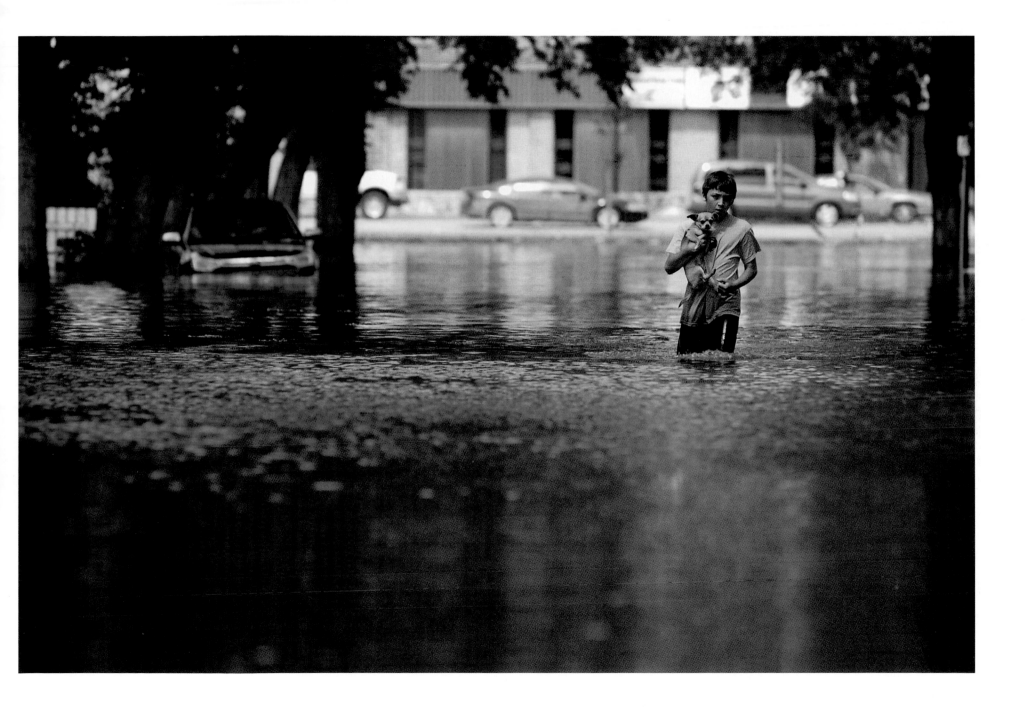

ABOVE A snowstorm hit North Dakota and Minnesota (pictured) in March 2009, while the two states were also recovering from massive flooding.
(Scott Olson/Getty Images, Postmedia archives)

RIGHT Tito Araneta was coated with ice after taking a run in −30°c temperatures in Winnipeg in January 2011.
(Brian Donogh/*Winnipeg Sun*)

FACING PAGE A sundog, seen here in Calgary in 2010, indicates very cold weather is looming. (Gavin Young/*Calgary Herald*)

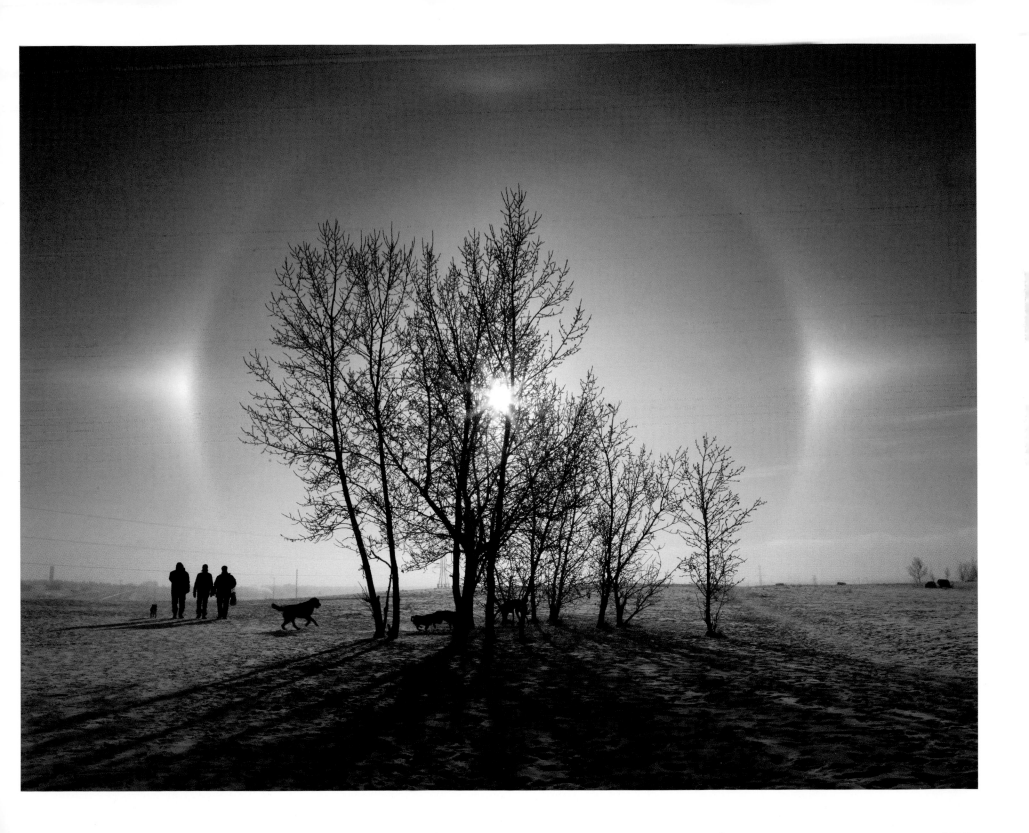

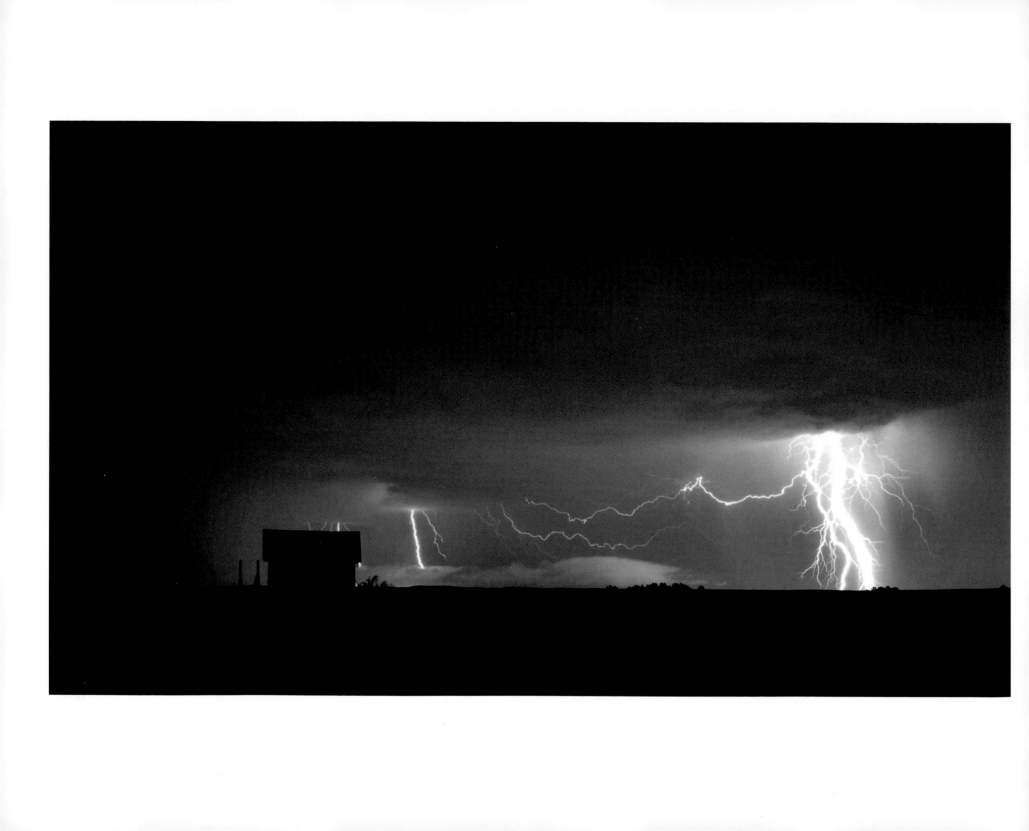

Prairie people discuss the weather to such an extent that English classes for newcomers often address the question of why the weather is such a hot topic. Media outlets in Canada also reflect this weather interest. They published 229 percent more weather stories in 2014 than did media in any other country in the world, says Influence Communication, an information-monitoring firm.

It's readily apparent, however, that people do indeed dwell on the weather. Just look at our language. It's infused with weather idioms and metaphors. People take a rain check or save for a rainy day. They throw caution to the wind or perhaps get wind of something. They steal someone's thunder. Break the ice. Get snowed under. Chase rainbows.

The list of weather-related phrases that litter our language is a long one, but do Prairie people obsess over the weather more than others? That's likely the case, says one Environment Canada spokesman, who notes that the agency's greatest number of web hits comes from Winnipeg. The Prairies' deep historic and economic ties with agriculture also give rise to much weather talk and weather watching.

It also seems that Canadians take their weather very seriously. A poll from Goodyear Canada showed 70 percent of Canadians paid more attention to their local weather forecaster than they did to their mayor. (As an aside, 22 percent also said they paid more attention to their local weather forecaster than they did to their significant other.) Without the weather, we may not have much to talk about at all, the joke goes.

So, why all the weather talk? For starters, people discuss the weather because it's interesting. For both Canadians on the Prairies and Americans living on the Great Plains, the weather can bring wild swings of temperature and conditions from day to day. Example? In Pincher Creek, Alberta, in 1962, the mercury rose from −19°C to 22°C in just one hour. The Black Hills of South Dakota

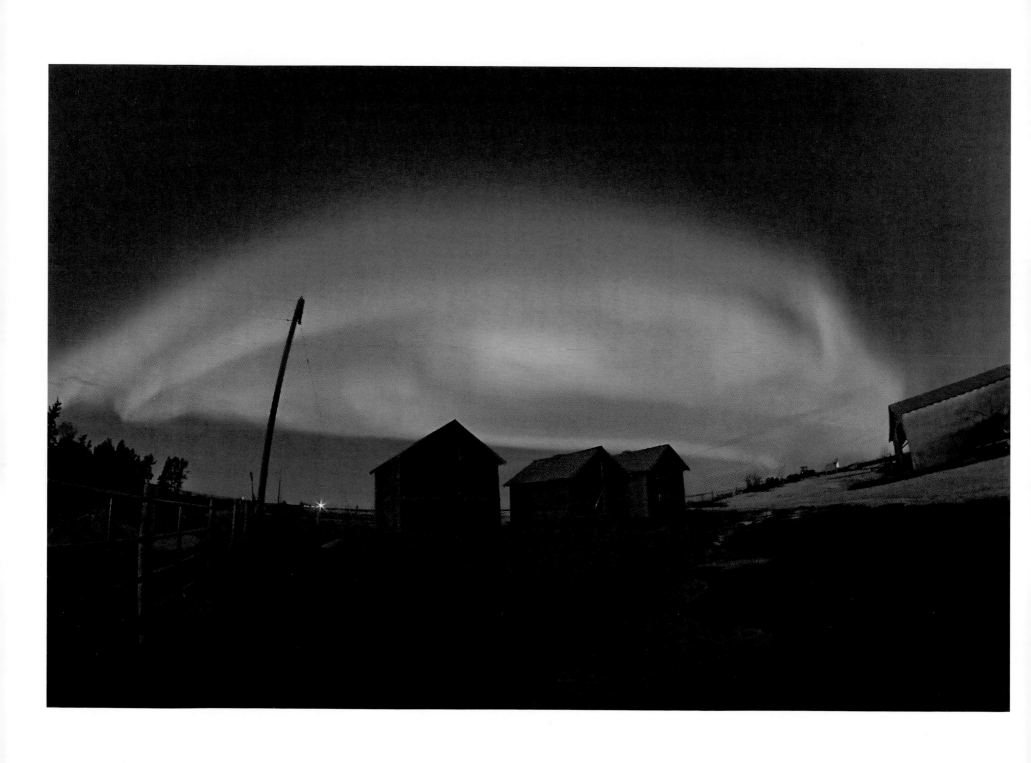

possess an equally startling record. On January 22, 1943, the temperature at 7:30 a.m. was −20°C. A chinook wind began blowing and within two minutes, the mercury had reached 7°C. Shortly afterwards, the temperature peaked at 12°C; but in less than an hour the chinook stopped and the temperature was back to −20°C.

Across the Great Plains, other interesting weather stories abound. A January day in 2015 saw Montana hit a temperature colder than that recorded on the planet Mars. A 1958 tornado in Saskatchewan picked up pigs from one farm and scattered them over another, five kilometres away. A 1936 Canadian heat wave led to the death of 1,180 people. And a 1921 rainstorm saw frogs fall from the sky over downtown Calgary. When it comes to the weather, something is always happening.

Weather talk on the Prairies is also essential. Any given day can require an umbrella, a parka, or sunscreen. Entire industries have developed around Prairie weather, particularly winter. Car heaters, goose down jackets, snow tires, snow blowers, snow shovels, and booster cables are just some of the items that help us weather the winter. Prairie winters keep many people employed, too, from tow truck drivers and sanding truck operators to snow removal experts and ski hill operators.

Icy weather, of course, isn't just something to be endured. For many, it's an opportunity to partake in a myriad of activities. We strap boards on our feet and slide down hills; we lace up blades and glide across ice; we throw rocks or chase pucks across rinks and ponds. Winter pursuits are part of our identity.

Living on the Prairies means we not only survive the weather, we thrive because of it. We open windows to occasionally get fresh air, even when it's −20°C. We put snow tires on bicycles. We throw festivals and carnivals to celebrate the season.

Through it all, there's a silent beauty that accompanies winter. Frost leaves a breathtaking blanket on everything around us. Huge snowflakes fall in a magical silence. Snow on the ground provides a satisfying crunch underneath each step taken.

Winter also helps us appreciate the seasons that follow: the blooming of spring, the warmth of summer, and the burst of autumn. The dramatic differences between seasons help define weather on the Great Plains.

The climate itself, however, is altering. Prolonged droughts will strike much more often in a much warmer climate, David Sauchyn told Postmedia in recent months. Sauchyn—a senior research scientist at the University of Regina's Prairie Adaptation Research Collaborative—says that much work is still needed to determine exactly what climate change will mean for weather in the long run.

More intense weather events aren't a sure bet quite yet, but preliminary research points in this direction. Larger wildfires, more droughts, shrinking snow packs, and more uncertain weather disturbances are all possible.

Extreme weather is increasingly a concern for rural communities, adds Sauchyn, who oversaw a five-year study of climate extremes in the Americas. Cities have more infrastructure to deal with disaster management. Additionally, rural areas are more vulnerable because weather affects many people's livelihoods as farmers. "Climate affects living," Sauchyn says.

Meanwhile, Agriculture Canada predicts that temperature increases due to climate change could be more pronounced on the Prairies than in some other parts of the country. According to studies cited on its website, the growing season is getting longer and hotter. Winters and springs are getting wetter. Summers are getting drier.

An extended growing season would be an economic boon for the agriculture sector. But, at the same time, warmer temperatures may bring more cases of extreme weather, which in turn can lead to increased crop disease, weeds, and insects.

The predicted rise in extreme weather could also result in more floods, which concerns experts. The southern Alberta floods of 2013, for example, prompted a massive new study. In 2016, the federal government announced a grant of $77.8 million to the University of Saskatchewan for a seven-year program to develop new ways of forecasting and mitigating threats such as floods and droughts. Renowned U of S hydrologist John Pomeroy, who is associate director of the program, told Postmedia that this sort of research is increasingly important as extreme weather events multiply.

"We're doing it because climate warming and associated severe weather have coupled with unprecedented growth in population and industry across Canada," Pomeroy says. The result is that fresh, safe, and plentiful water is no longer guaranteed. Canada needs to be able to better cope with both droughts and floods to ensure it retains its high quality water supply, he adds.

Federal and provincial governments agree that climate change and extreme weather are significant concerns that need to be addressed. Ottawa directed federal infrastructure money to disaster readiness projects last year. Many of the provinces, meanwhile, are revamping their approaches to disaster prevention, preparedness, response, and recovery.

When extreme weather does turn disastrous, a common theme emerges. If the weather is at its worst, people are often at their best. It's part of Prairie people's DNA. In pioneer days, an entire

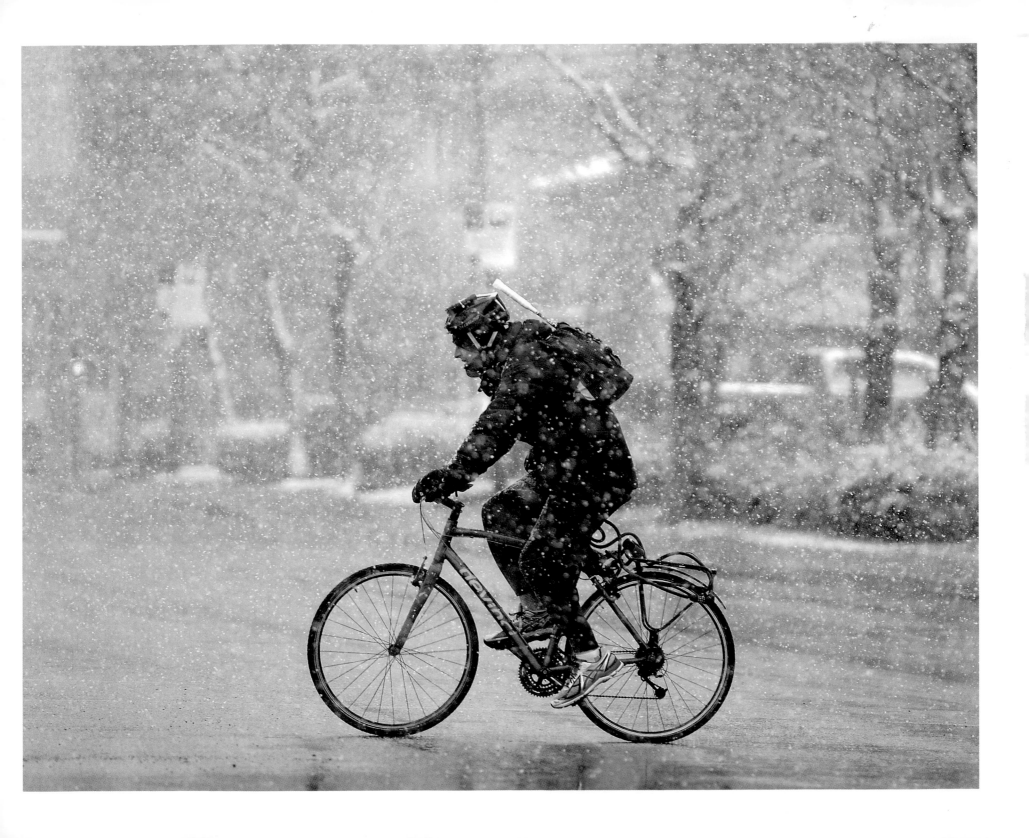

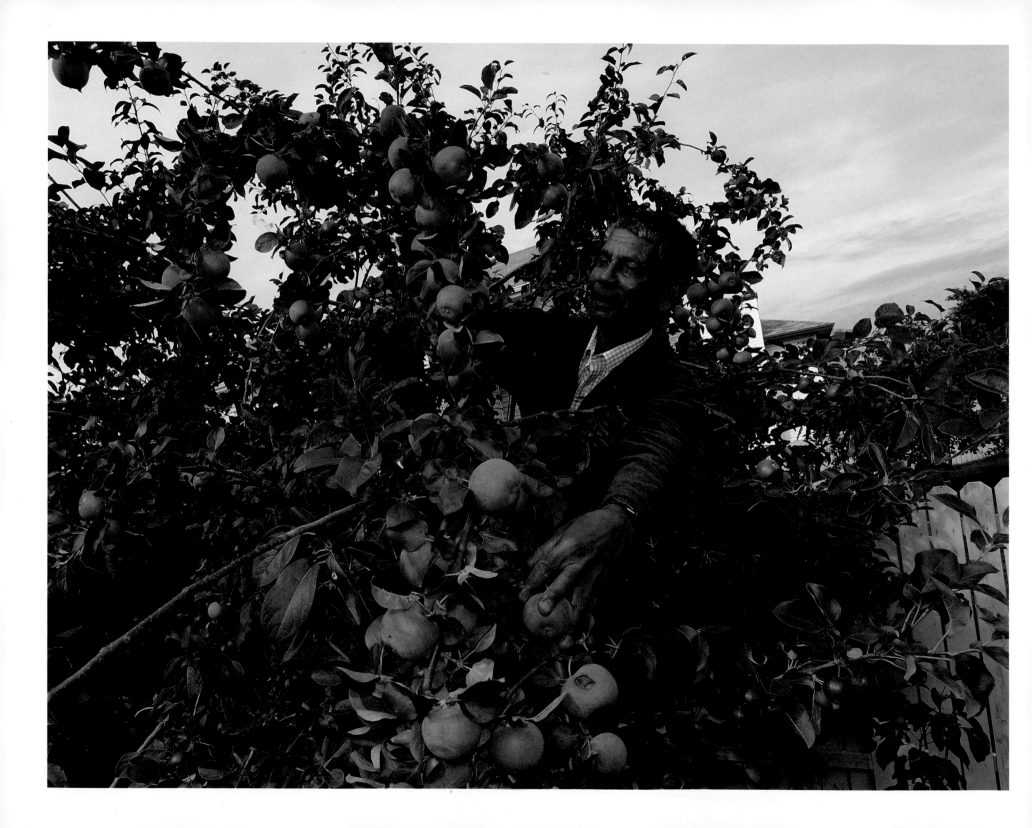

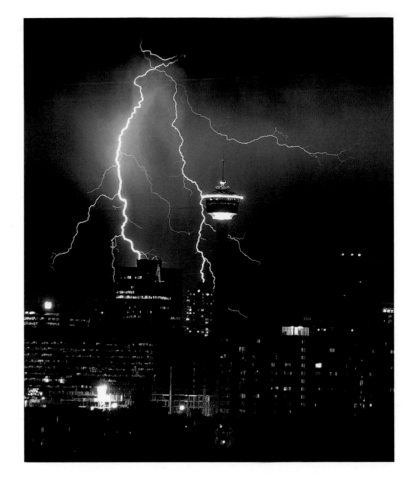

community would show up to help a farmer if a grass fire claimed his barn, house, or crops. When a large-scale disaster such as the 1912 Regina Cyclone struck, people from far and near opened up their hearts and wallets to help. "The splendid spirit of optimism—energetic optimism—is continually becoming more apparent," the *Morning Leader* (a forerunner of the *Regina Leader-Post*) reported shortly after the tornado hit.

The tradition stands strong in modern times, too. When the Red River spilled its banks during a massive flood in 1997, the volunteers who fought back the waters numbered more than 75,000 in Manitoba, North Dakota, and Minnesota. When calls went out for help after the Alberta floods of 2013 and the Edmonton tornado of 1987, the responses were so overwhelming that thousands of volunteers couldn't be accommodated.

When weather events of wind, water, ice, or fire intensify to catastrophic proportions, people come together to rise above the mud, ashes, and debris that surrounds them to help friends, family, neighbours, and strangers. This is the legacy of people of the Prairies. It's how they're born and raised.

Those who survive a weather-related disaster move forward, but they never forget the devastation. Memories remain, perhaps best reflected by a tree that grows in Edmonton. Richard Heetun was one of the first rescue workers on the scene of the 1987 tornado in that city. He noticed a twig with a root attached in the middle of the rubble. He decided to take the twig with him as a remembrance of the event. Over the years, he turned the twig into what he calls the Tornado Tree. He planted it and began grafting branches from other fruit-bearing trees onto this special sapling. Today, it's a six-metre-tall tree that produces apples and pears each year. The fruit hangs from twenty-seven different grafts, one for each of the lives lost in the tornado.

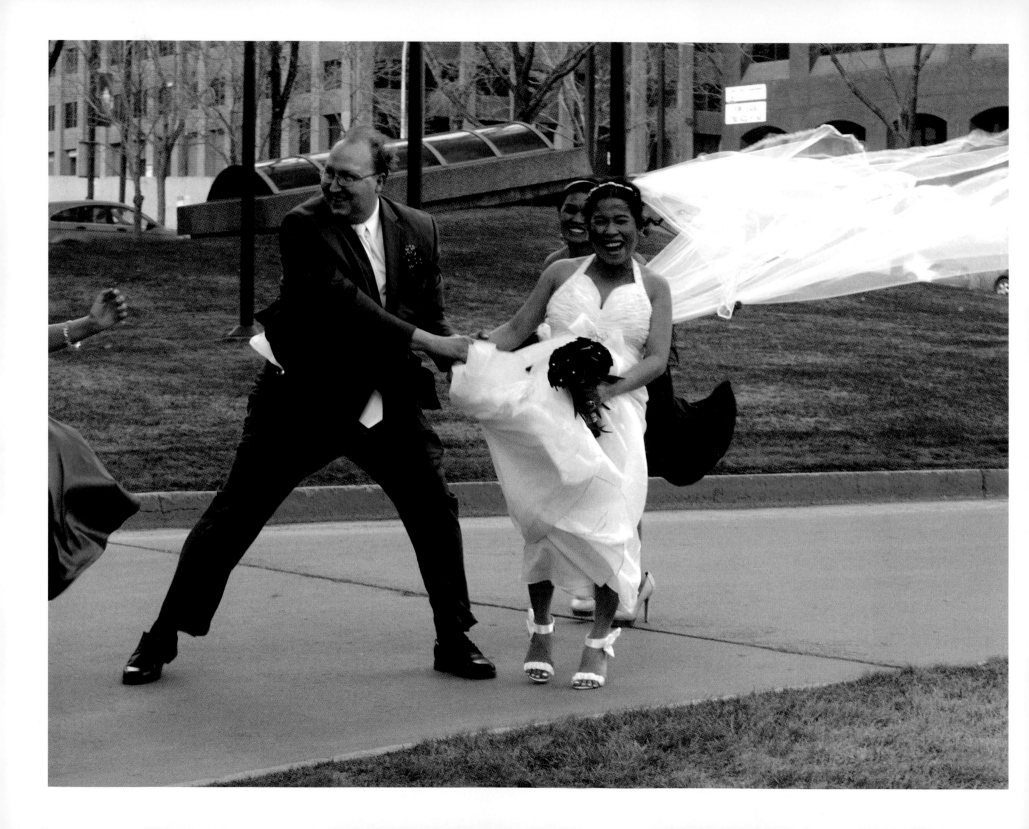

ONE

WIND

To live on the Prairies is to live with wind. Sometimes mild and sometimes wild, the wind has long shaped the Great Plains and its peoples. It sweeps across endless stretches of grassland and farmland, a force that contours and cuts the terrain.

Indigenous people share stories of the wind, giving it a myriad of meanings. Legends reveal that the wind can represent fighting brothers, a grandmother's love for her grandson, or even become a harbinger of change, not necessarily seen but always felt. The wind of the Prairies has also inspired contemporary writers, artists, and musicians. Canadian author W.O. Mitchell wrote of it in "Who Has Seen the Wind." Songwriter Ian Tyson sang of it in "Four Strong Winds." The wind is their muse.

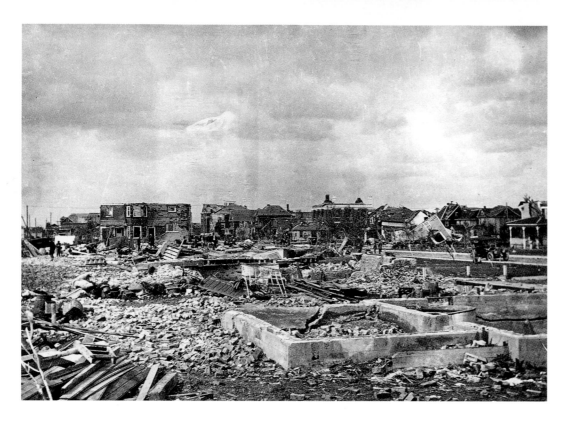

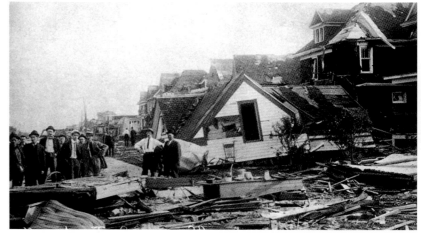

Wind is most memorable, however, when weather turns destructive. Relentless gusts, coupled with drought, created the infamous dust storms of the Dirty Thirties, for example. The wind whipped up topsoil and spawned storms that stretched for kilometres, sometimes leaving farms, towns, and cities covered in dust for days and even weeks.

Those who live on the Prairies must also survive the winds of winter. The temperature on a frigid day can plummet when northern blasts of air arrive and produce a dangerous wind-chill factor. On the flip side, some parts of the Great Plains—largely in southern Alberta and parts of Montana—occasionally benefit from warm winter winds known as chinooks.

TOP LEFT The 1912 Regina Cyclone devastated the city, which was in the midst of a housing boom. Pictured is the corner of Lorne Street and 13th Avenue. (*Regina Leader-Post* archives)

TOP RIGHT The Regina tornado was so strong that it blew the house in the foreground off its foundation and across the street. (Postmedia archives)

FACING PAGE More than 2,500 Reginans were left homeless and twenty-eight people were killed, making it Canada's deadliest twister. (Postmedia archives)

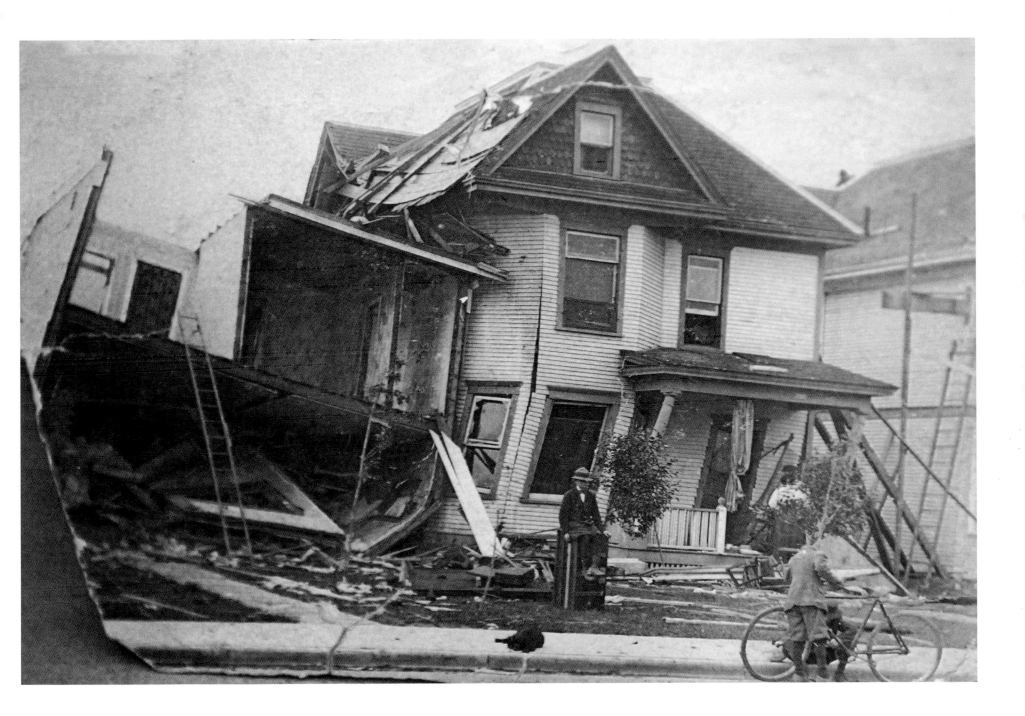

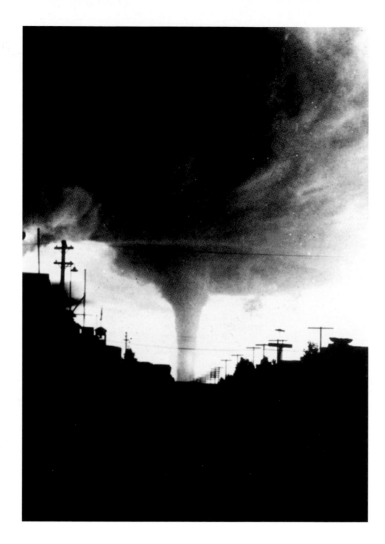

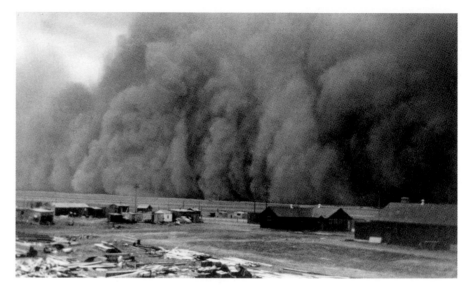

TOP LEFT This 1927 tornado in Vulcan, Alberta (130 kilometres southeast of Calgary), levelled many structures, including the town's curling rink. (Postmedia archives)

TOP RIGHT During the Dirty Thirties, winds whipped up dust storms across the parched Prairies; these storms still occasionally occur during extremely dry summers. (*Calgary Herald* archives)

Although chinooks bring welcome respite from winter's bitter cold, the temperature swings they create are wild. The Montana town of Loma experienced the most extreme twenty-four-hour temperature change ever recorded on January 15, 1972, when a chinook took the temperature from −48°C to 9°C. And when the Winter Olympics came to Calgary in 1988, they became the warmest Winter Games at the time. Chinook winds blew in, raising temperatures to near-record highs, melting snow at crucial venues, and leading to event delays. On February 26, for example, the high in Calgary was 18.1°C, almost matching the high of 19.4°C reached in Miami, Florida, that same day.

The prairie winds that leave the most indelible mark, however, are the tornadoes. Biblical references to tornadoes describe these whirlwinds as tools of divine judgment. While prairie twisters aren't *actually* a sign that the world is ending, they are frightening.

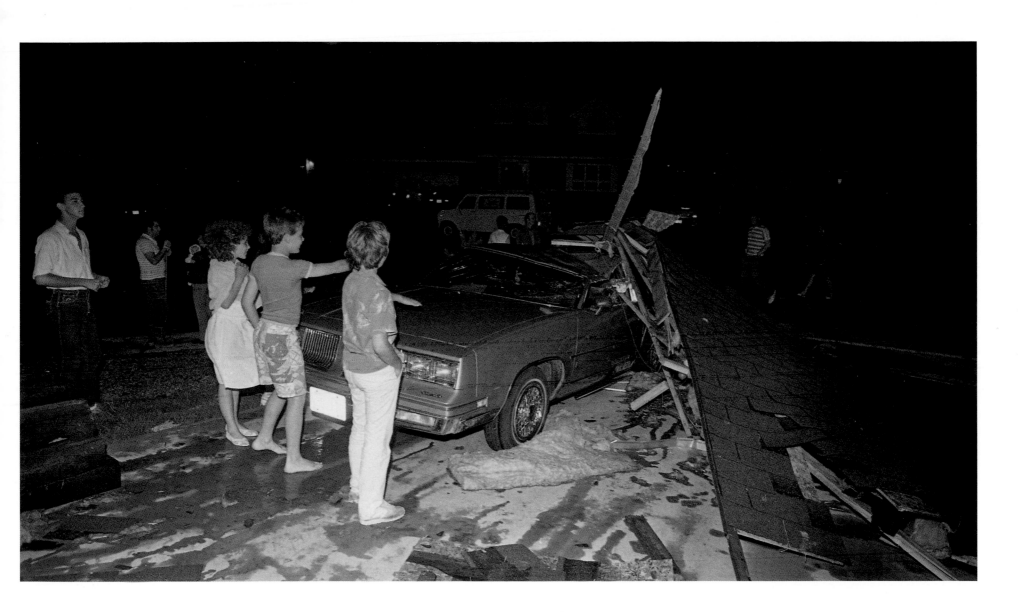

This roof from a Saskatoon house was carried through the air and slammed onto a car during the June 1, 1986, tornado.

(Provincial Archives of Saskatchewan, *StarPhoenix* Collection S-SP-A25674-2)

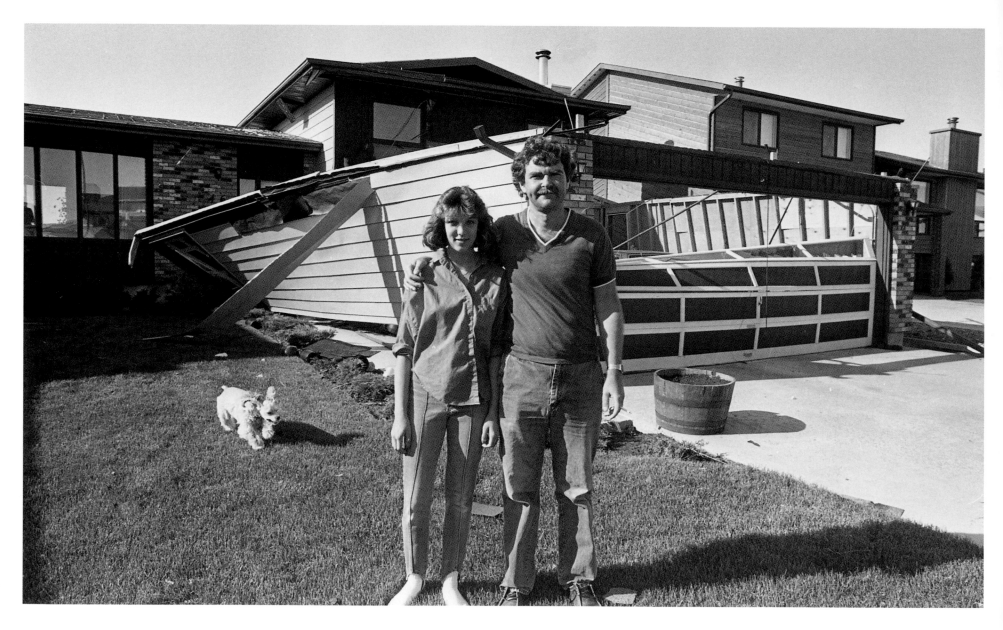

Don Gulak, with daughter Michelle,
lost the roof of the family garage to
the 1986 Saskatoon twister.

(Provincial Archives of Saskatchewan, *StarPhoenix*
Collection s-sp-a25674-15)

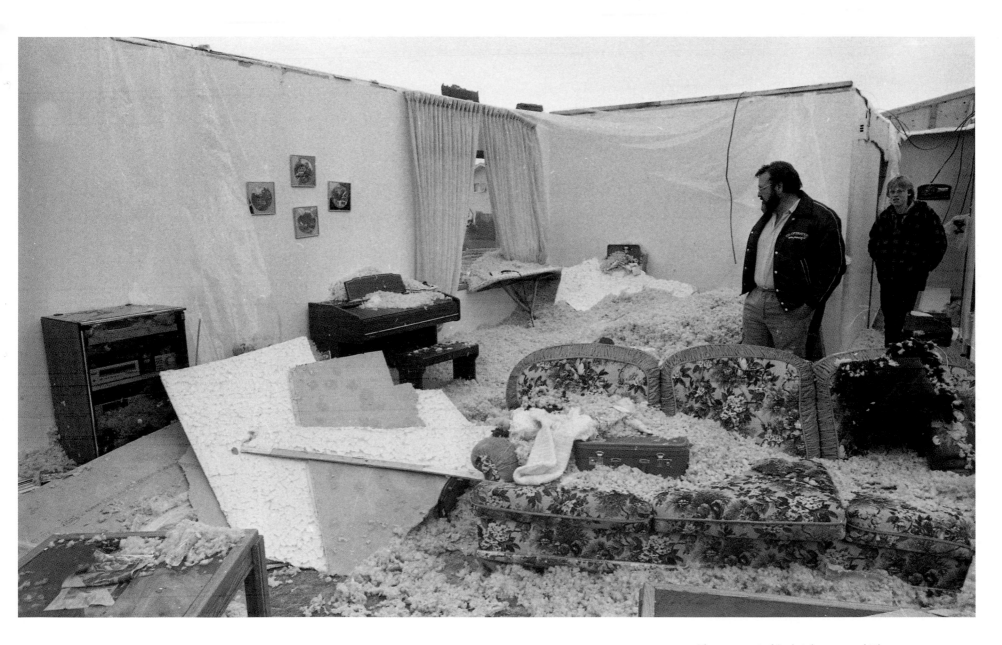

The same part of Saskatchewan was hit by a vicious storm about sixteen days later. Winds up to 95 km/h ripped the roof off the Saskatoon home of Larry Rupert, who surveyed the damage here with son Brett.

(Provincial Archives of Saskatchewan, *StarPhoenix* Collection s-sp-a25750-36)

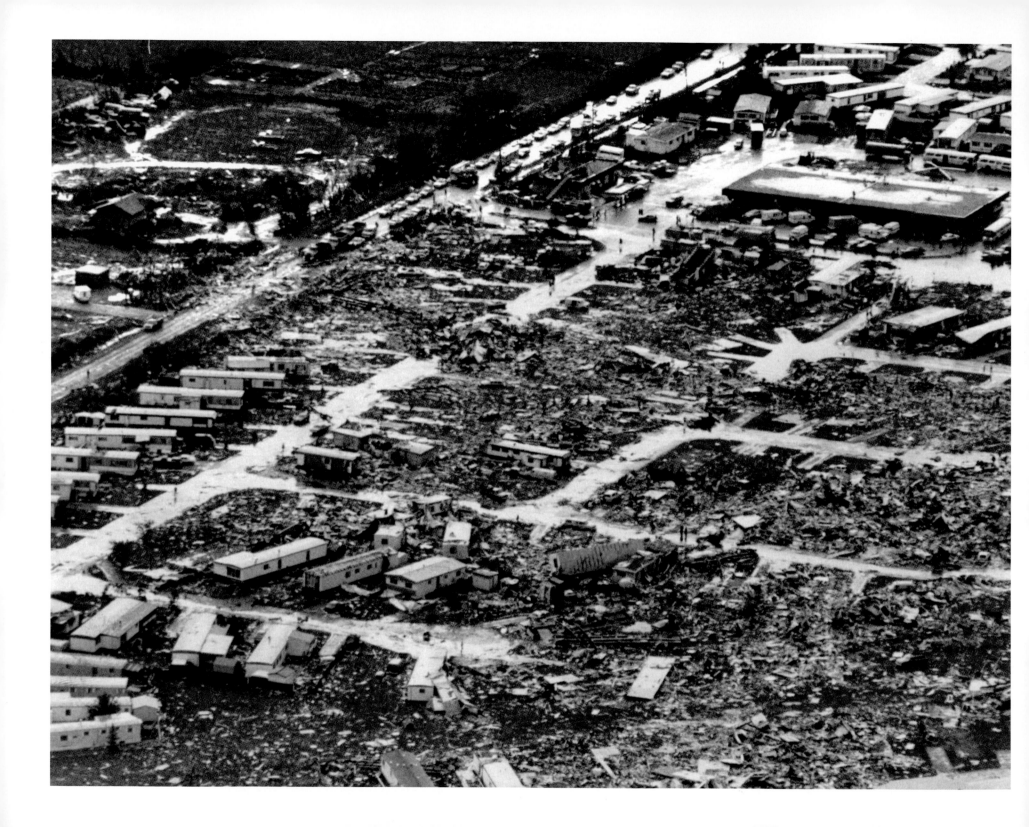

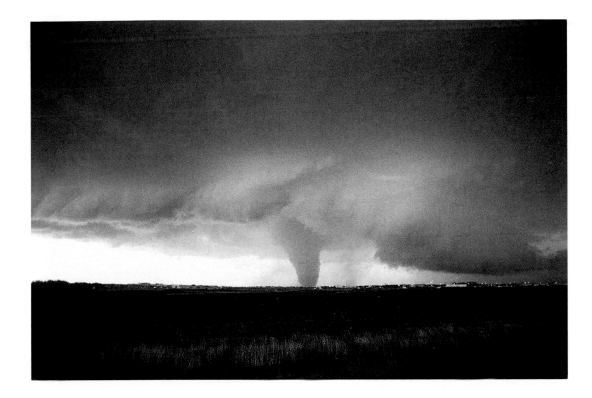

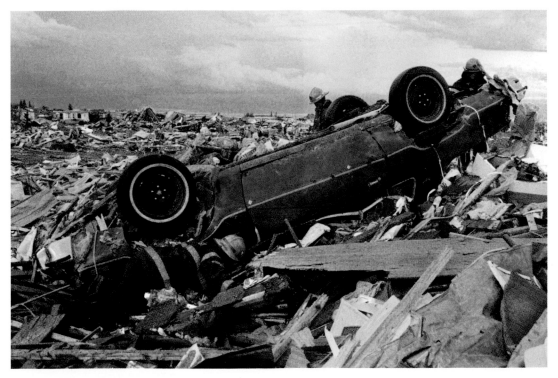

FACING PAGE The tornado that ripped across the east side of Edmonton in 1987 was Canada's second deadliest, killing twenty-seven people and injuring about six hundred more. (*Edmonton Sun* archives)

TOP LEFT The Edmonton twister was classified as an F4, meaning wind speeds reached 333 to 418 km/h.
(Steve Simon/*Edmonton Journal*)

BOTTOM LEFT After the tornado, firefighters carefully searched the debris for survivors and victims at Edmonton's Evergreen Mobile Home Park.
(Tom Braid/*Edmonton Sun*)

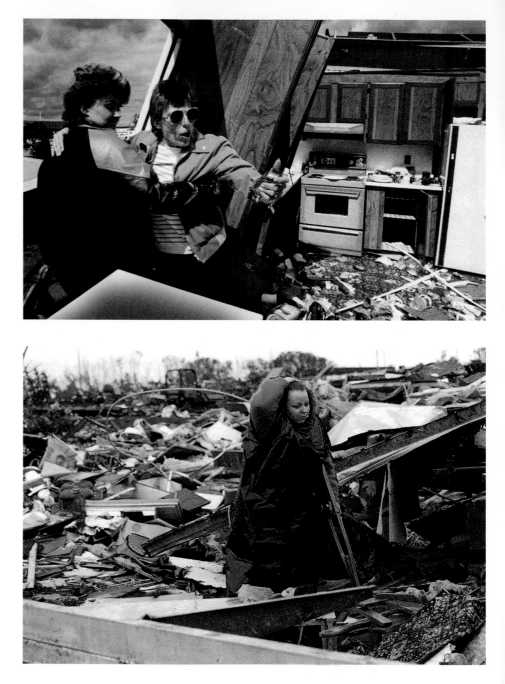

When a severe twister tears through a town, the devastation and destruction–along with recovery and repair–become pivotal moments for that community, as was the case in Regina in 1912. At the time, the 30,000-person city was a Prairie boomtown that had been named the capital of Saskatchewan just six years earlier. But on June 30, a tornado struck with such force that one witness described it as sounding like "40 million shrieking devils let loose at once." Hundreds of buildings were destroyed, 2,500 people were left homeless, and 28 were killed, making the Regina Cyclone the deadliest tornado in Canadian history.

Visitors, residents, the RCMP, and the Saskatchewan militia all came together to rescue and rebuild. An army of seven hundred carpenters quickly began fixing as many homes as possible, while all Boy Scouts were called upon to volunteer as messengers.

"Regina (is) rising beneath her burden of grief and ruin," the *Morning Leader* reported within a few days of the twister. "The city of horror has become a beehive of industry–a juggernaut of determination that her material loss will not deter steady and sure progress."

Resilience–and communities coming together to overcome tragedy–is a theme that repeatedly emerges when looking at the history of tornadoes on the Prairies. In August 1944, a tornado

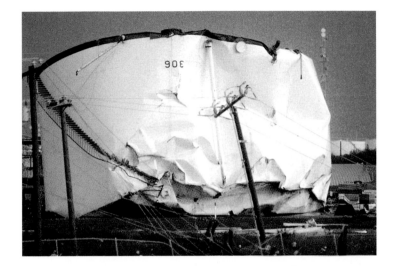

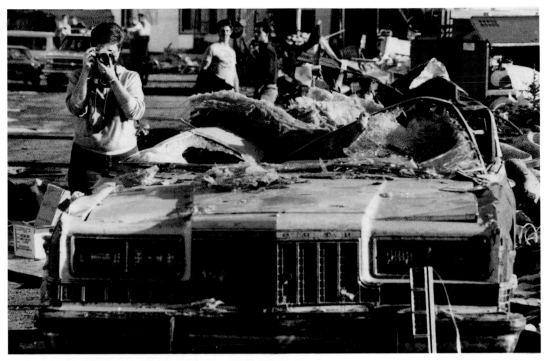

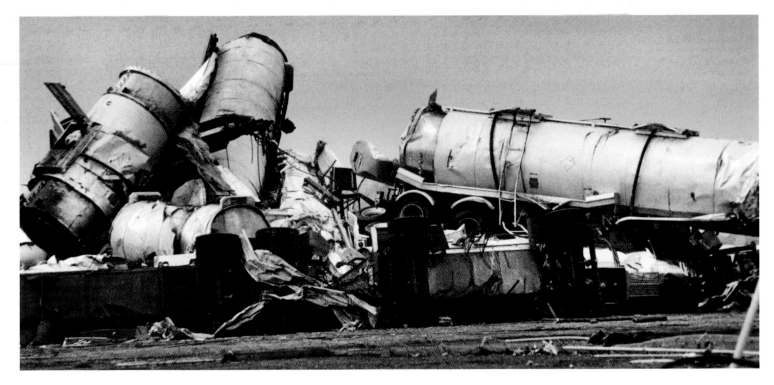

TOP LEFT This oil tank on Refinery Row, off Baseline Road, was flipped over by the 1987 tornado.
(Tom Braid/*Edmonton Sun*)

TOP RIGHT Glenda Merriam documented the damage to her Plymouth at Evergreen Mobile Home Park.
(*Edmonton Sun* archives)

LEFT Vehicles and equipment, piled up here on Refinery Row, were tossed about like toys by the tornado.
(Robert Taylor/*Edmonton Sun*)

RIGHT In addition to the massive tornado that created chaos in Edmonton (pictured), seven other twisters touched down in central Alberta on July 31, 1987. (*Edmonton Sun* archives)

FACING PAGE The twister's destructive path turned Alberta Truss, off Baseline Road, into a pile of rubble. Total damages caused by the tornado in the Edmonton area were more than $330 million.

(*Edmonton Sun* archives)

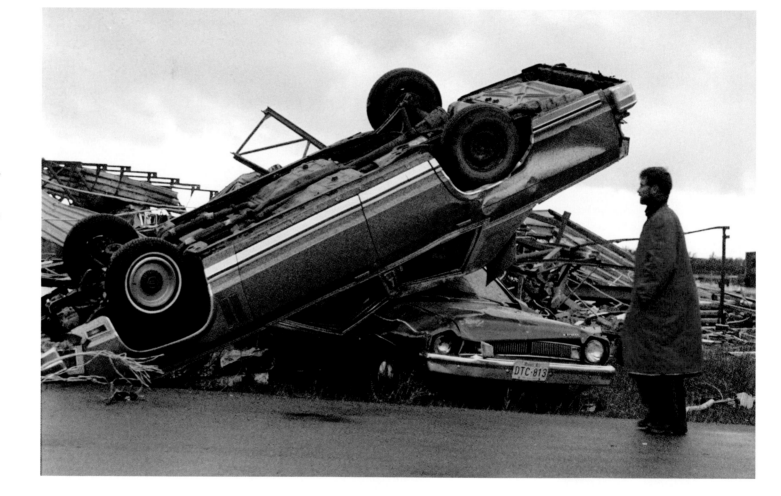

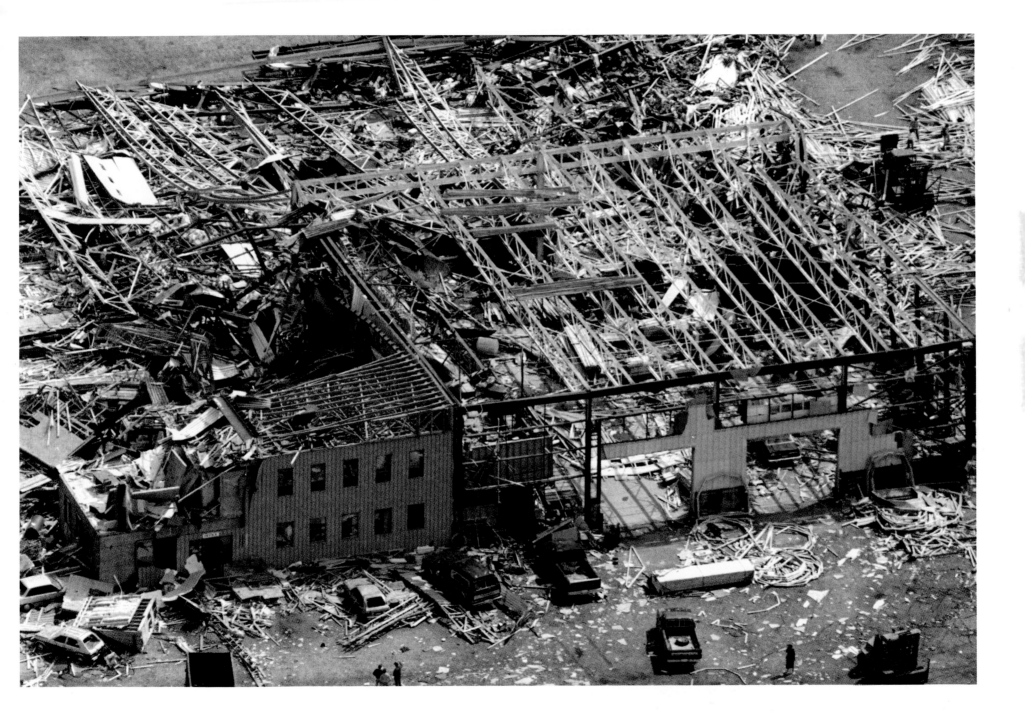

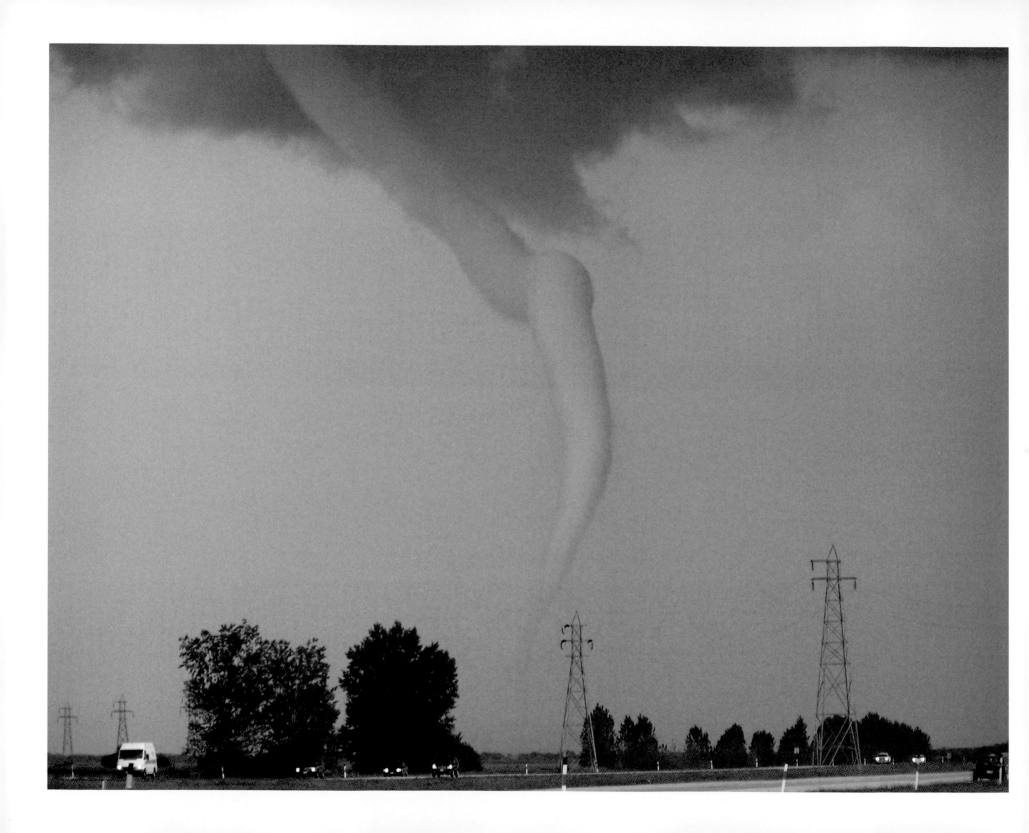

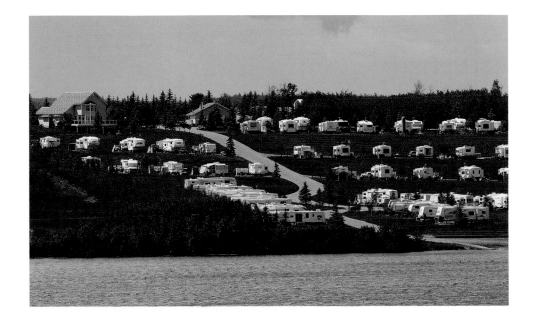

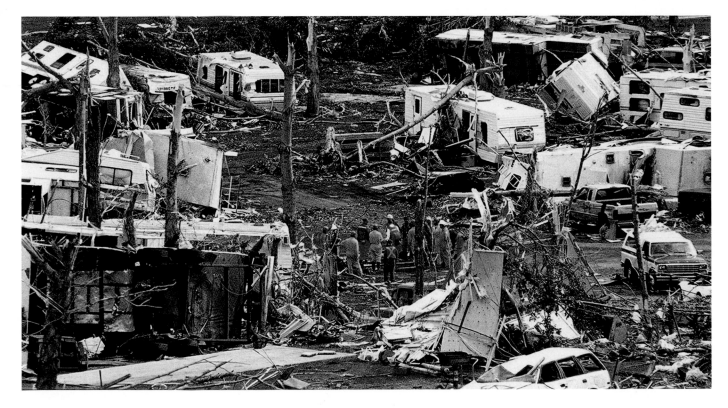

FACING PAGE Only one Canadian tornado has been an F5; it hit Elie, Manitoba, in 2007, with winds reaching 410 to 512 km/h. In 2013, the tornado rating system changed to the Enhanced Fujita Scale and now the most severe tornadoes are called EF5s, with winds reaching more than 315 km/h. (Wayne Hanna/Postmedia archives)

ABOVE On July 14, 2000, a tornado struck 25 kilometres southeast of Red Deer at Green Acres campground and RV resort on Pine Lake, seen here one year after it was rebuilt. (Postmedia archives)

LEFT Trailers and vehicles were tossed everywhere by the Pine Lake twister. It killed 12 people and injured more than 140 others. (Postmedia archives)

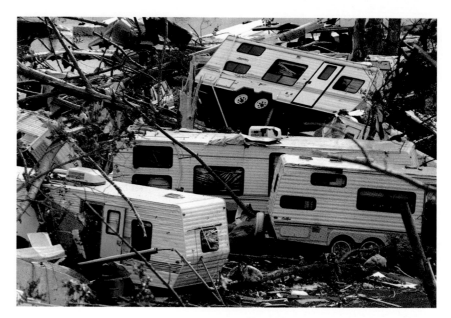

THIS PAGE TOP The force of the Pine Lake tornado saw hundreds of trees uprooted; it even tore grass from the ground. (*Edmonton Sun* archives)

THIS PAGE BOTTOM A rescue worker (middle) is comforted by colleagues after breaking down in tears. She'd recovered the bodies of six victims in the lake. (*Edmonton Sun* archives)

FACING PAGE In addition to destroying trailers, the twister picked up items such as axes and golf balls, embedding them deeply into trailer walls, trees, and vehicles. (Walter Tychnowicz/*Edmonton Sun*)

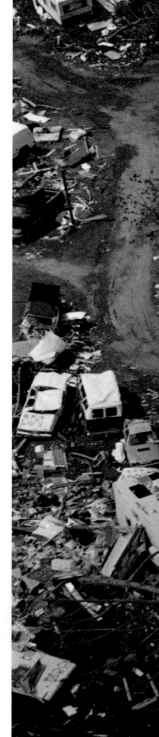

hit Kamsack, Saskatchewan, about eighty kilometres northeast of Yorkton, killing three and flattening much of the town. As word of the disaster spread, volunteers from dozens of nearby communities arrived to help, as did military personnel, Salvation Army relief squads, the Red Cross, and the entire staff of the City of Yorkton public works department.

Similarly, when a tornado tore through Edmonton in 1987 killing twenty-seven people, injuring six hundred, and damaging thousands of homes, the offers of assistance were so numerous that disaster relief co-ordinators had to turn some people away. When a relief centre asked for volunteers and donations, a huge traffic jam surrounded the building within an hour. Food donations arrived in such mass that Emergency Relief Services eventually gave excess groceries to the food bank. Later that year, they also gave thousands of pieces of clothing to Edmontonians in need; donation levels had

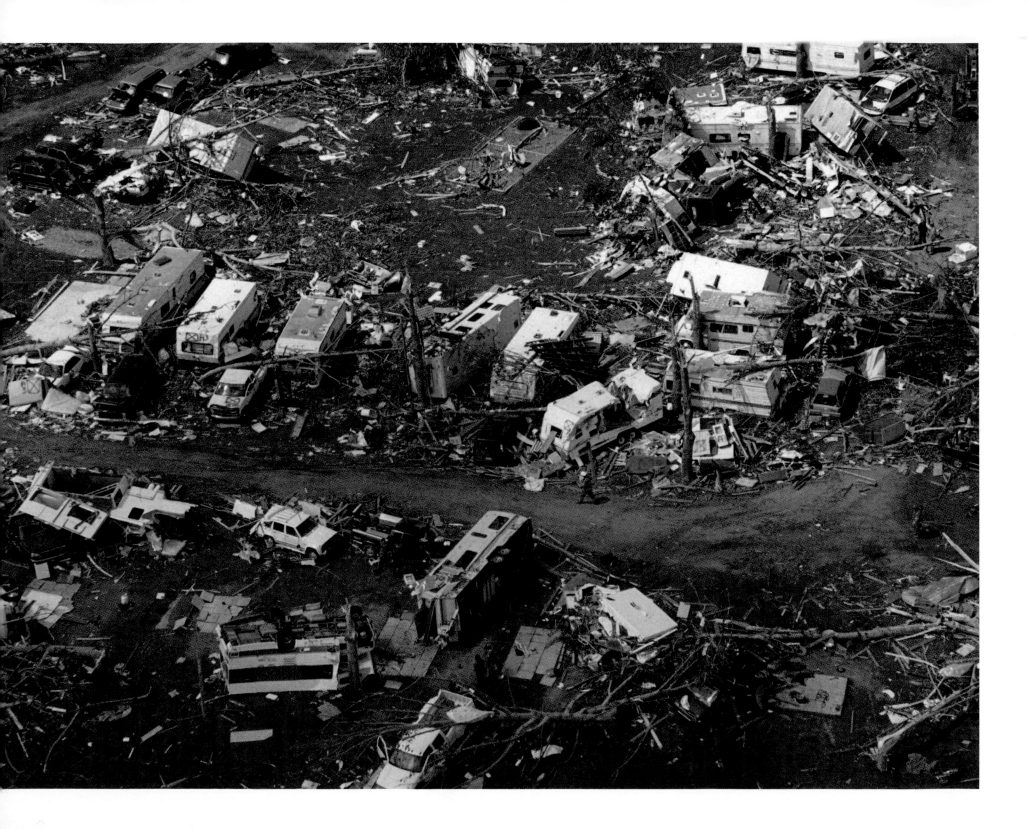

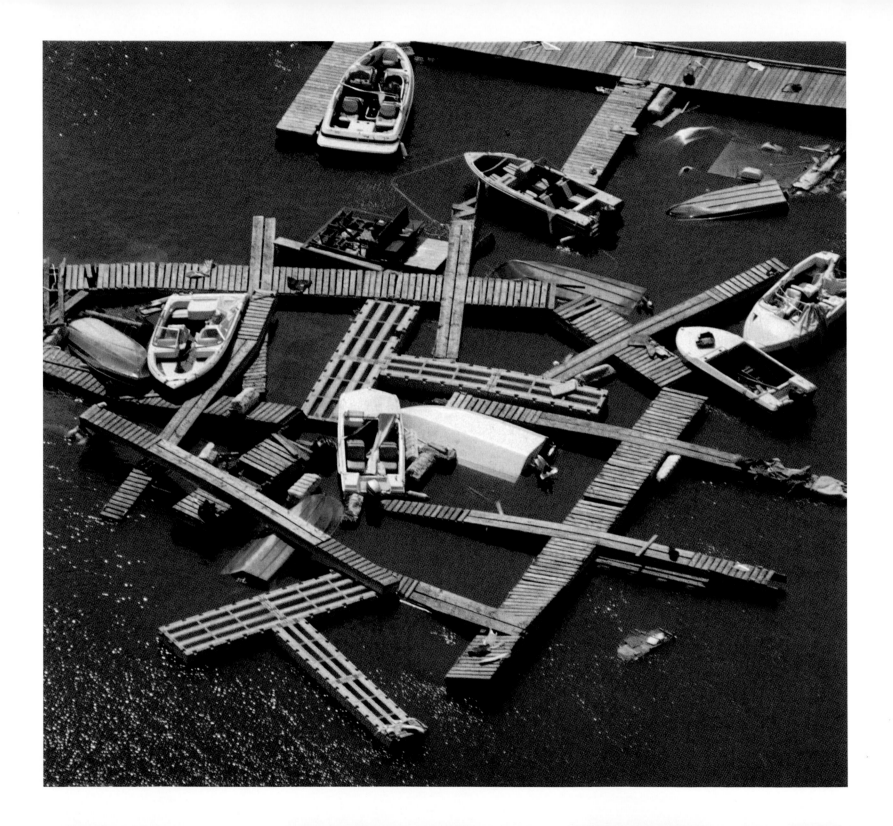

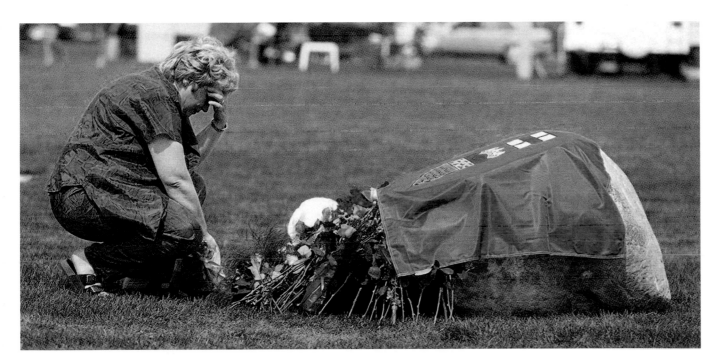

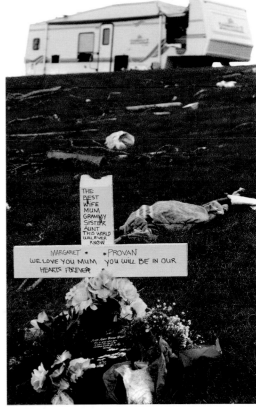

FACING PAGE The boat docks on Pine Lake were destroyed by the 2000 tornado, which also sucked fish out of the water and scattered them across the campground.

(Walter Tychnowicz/*Edmonton Sun*)

ABOVE LEFT A woman who lost a friend in the tornado reflects at a memorial in the Green Acres campground on the one-year anniversary of the Pine Lake disaster.

(Postmedia archives)

ABOVE RIGHT A family created this memorial in honour of the loss of a loved one in the 2000 tornado. (*Calgary Sun* archives)

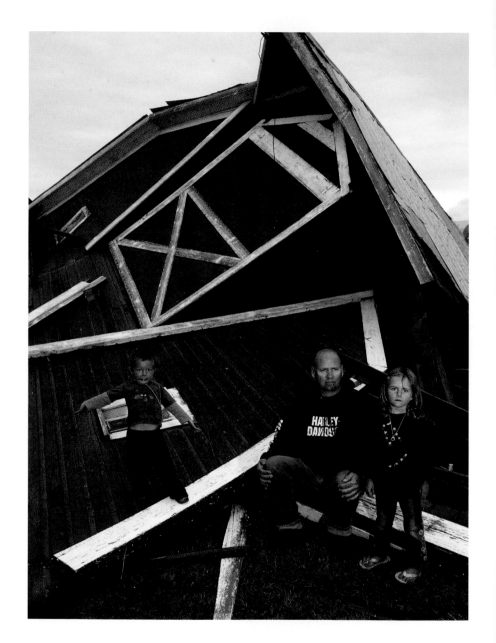

been so high that there were leftover items even after tornado victims were helped.

Benevolence also abounded in July 2000 after a tornado hit Green Acres campground and RV resort on Pine Lake, Alberta, about twenty-five kilometres southeast of Red Deer. When winds up to 330 kilometres per hour hurled trailers into the lake and damaged dozens more, 12 people were killed and 140 others injured. One Ontario man was so moved by photos from the disaster scene that he jumped in his car and drove halfway across the country to help. Locals, meanwhile, lined up for hours to donate blood to assist victims. And donations of food, clothing, and cash arrived from across the Prairies and the country.

When the chaos of the disaster settled weeks later, those who loved Green Acres campground vowed to rebuild it. Green Acres had always attracted a large number of people who spent summer after summer at the RV resort. After the tornado, their resiliency prevailed and more than two hundred returned the following year. Wild winds had damaged their summer retreat—but not their resolve.

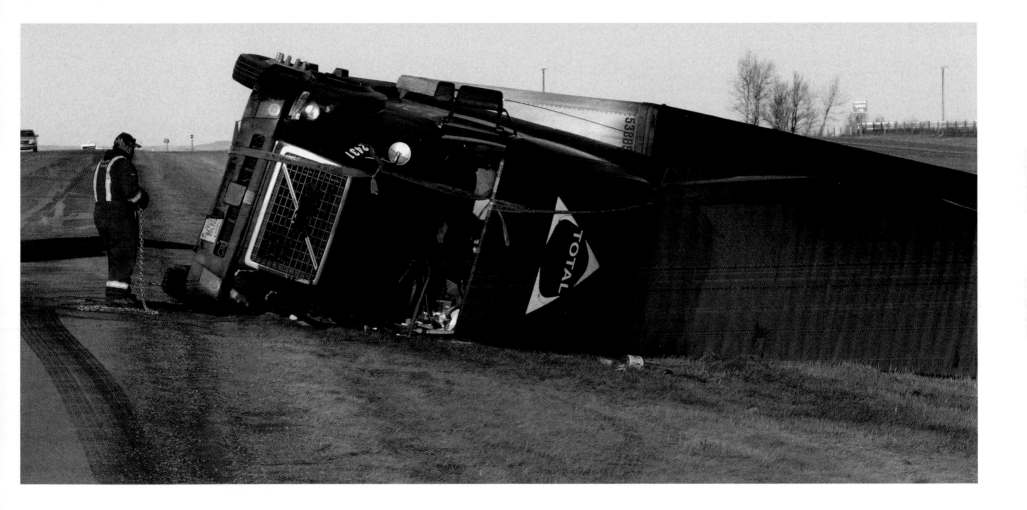

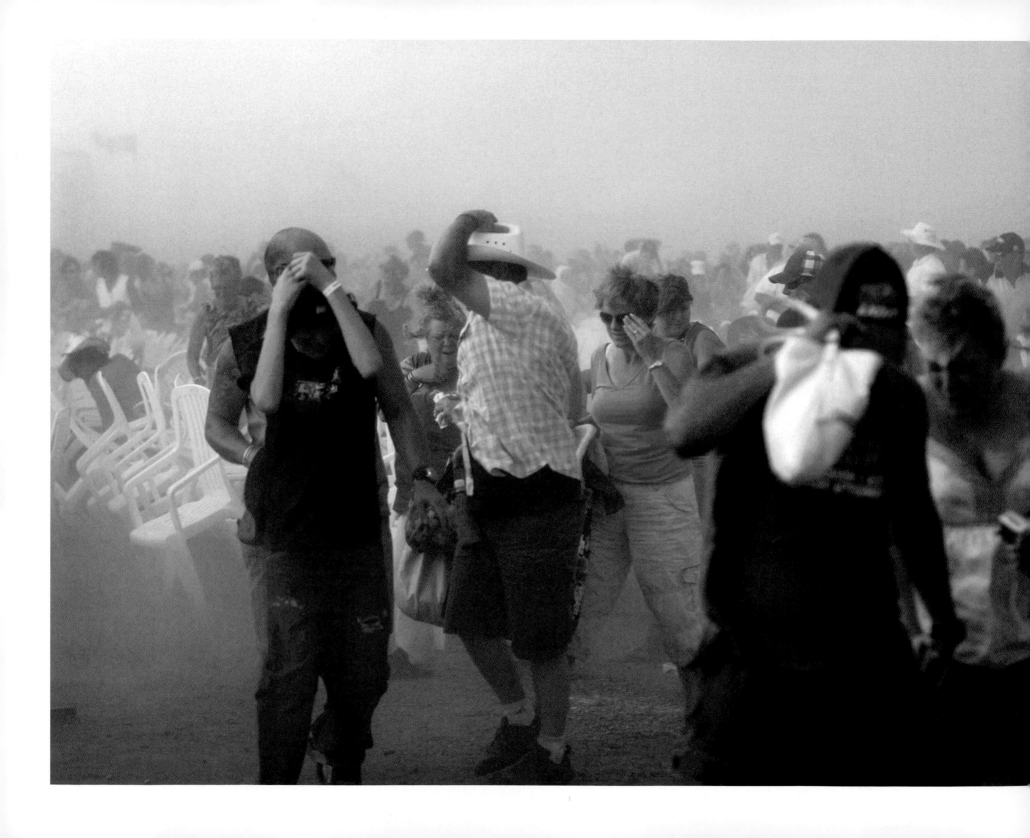

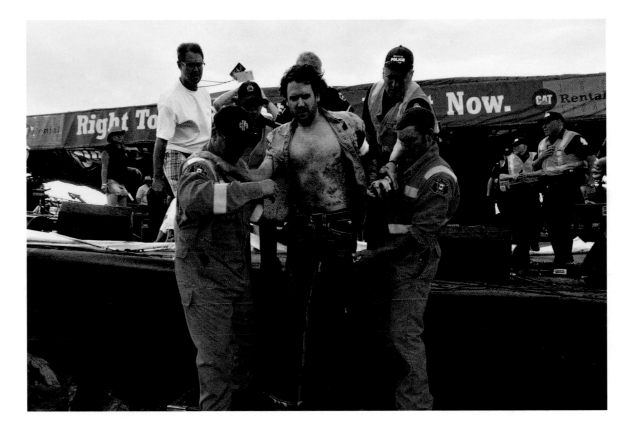

LEFT Fans at the Camrose Big Valley Jamboree, 95 kilometres south of Edmonton, fled a wicked windstorm in August 2009, just before the main stage collapsed, killing one woman and injuring dozens of others. (Ed Kaiser/*Edmonton Journal*)

ABOVE A Billy Currington band member, Alex Stevens, was rescued after being trapped for half an hour under the collapsed stage at the jamboree.

(Postmedia archives)

LEFT Weather lore says the intersection of Portage and Main in Winnipeg is the windiest, coldest intersection in Canada. It's an unproven legend, but the wind can blow strongly in the area, as seen on this January day in 2011.
(Marcel Cretain/*Winnipeg Sun*)

RIGHT A wind warning for central and northern Alberta was issued on January 15, 2014, with gusts reaching up to 120 km/h in Edmonton.
(Larry Wong/*Edmonton Journal*)

FACING PAGE Strong winds were also the weather story of the day on September 11, 2012, in the Edmonton area.
(Amber Bracken/*Edmonton Sun*)

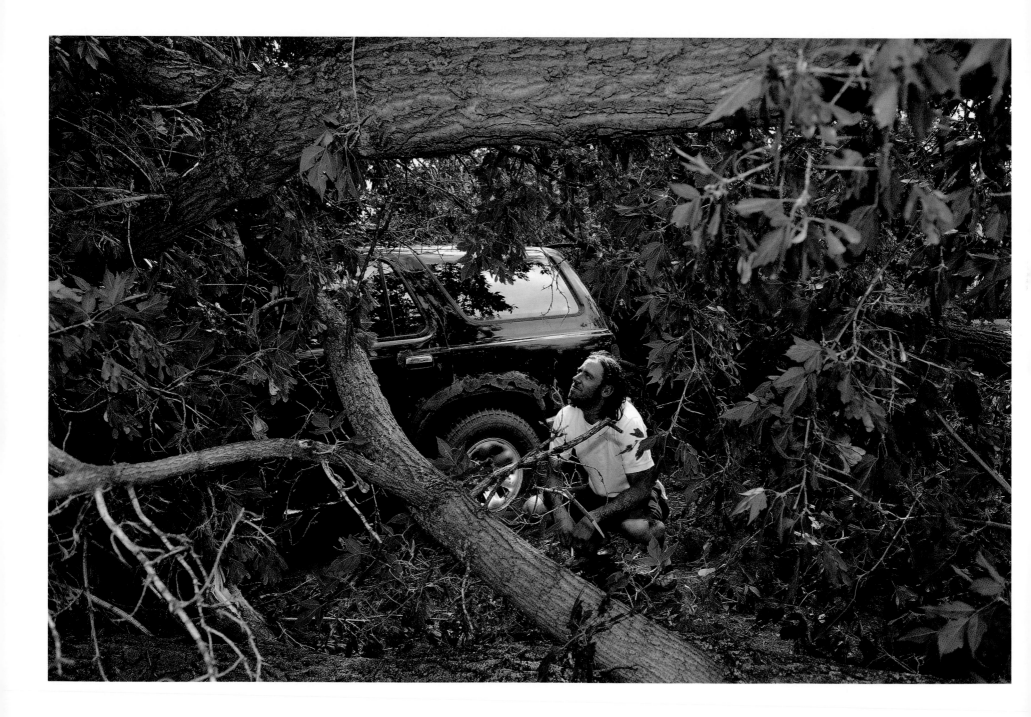

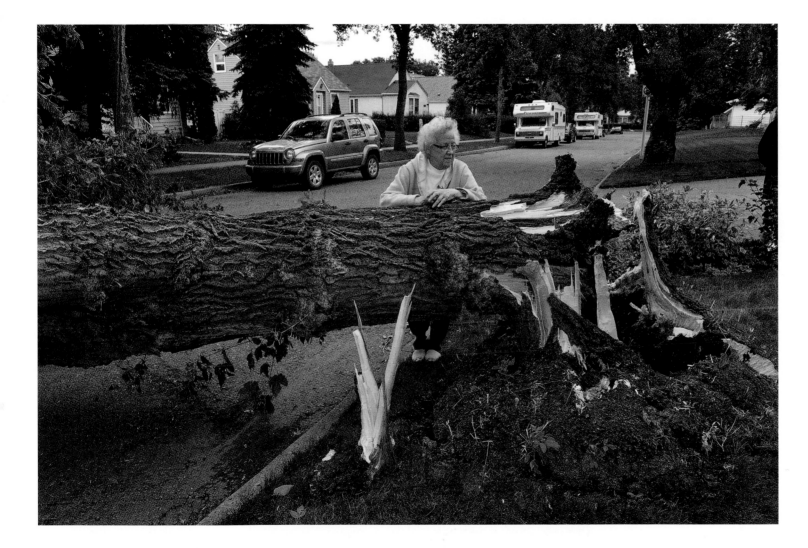

FACING PAGE A severe thunderstorm in the Edmonton region on July 18, 2009, brought winds that uprooted hundreds of trees, including this one that smashed onto James Miller's vehicle. (Larry Wong/*Edmonton Journal*)

LEFT Jean Atkin examined the massive tree in her front yard that fell to the 2009 Edmonton winds.

(Larry Wong/*Edmonton Journal*)

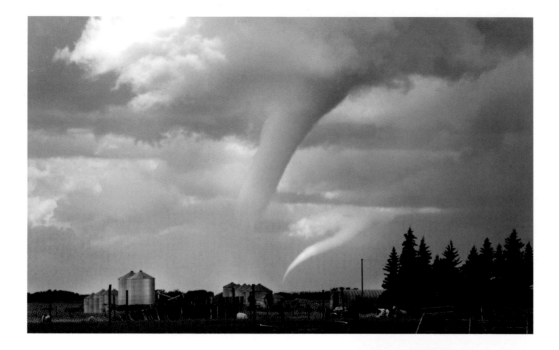

OVERLEAF LEFT Carson Derdall thought he was going to die July 5, 2014, when one of six Saskatchewan tornadoes on that day destroyed his farm south of Saskatoon. He and his family survived by hiding under a combine cutter and in a workshop.

(Liam Richards/*Saskatoon StarPhoenix*)

OVERLEAF RIGHT The Derdall family home was also heavily damaged by the twister, but the surrounding community quickly responded to help and just one week later, a potluck and silent auction raised more than $10,000 for the family.

(Liam Richards/*Saskatoon StarPhoenix*)

TOP A severe storm saw up to fifty funnel clouds and several tornadoes sweep through west-central Saskatchewan on June 15, 2012. (Andrew Spearin/*Saskatoon StarPhoenix*)

BOTTOM A May 26, 2014, tornado struck a workers' camp in Watford City, North Dakota, in the state's oil patch; nine people were injured. (AP photo/*Postmedia archives*)

FACING PAGE A tornado touched down south of Calgary, near Priddis, in summer 2015 as other funnel clouds swirled overhead. (Gavin Young/*Calgary Herald*)

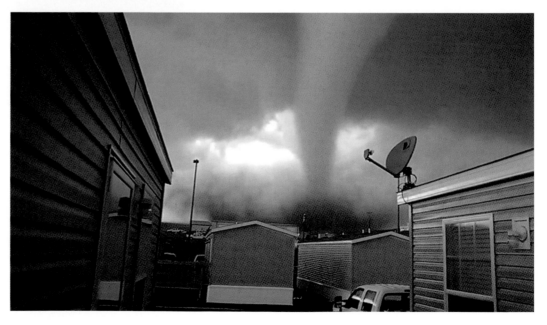

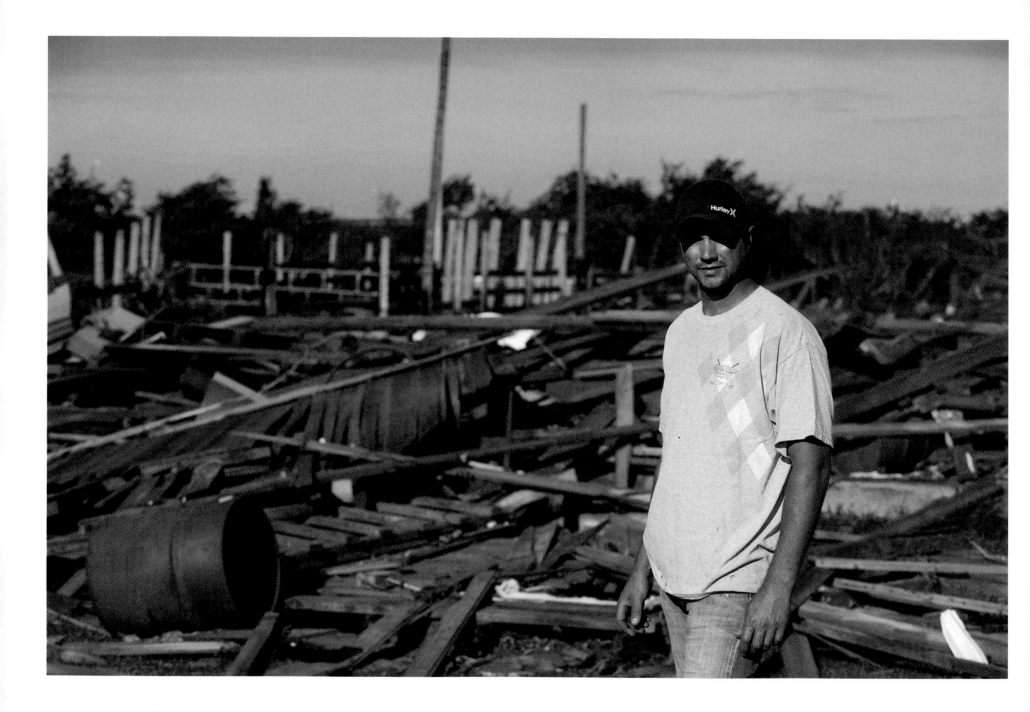

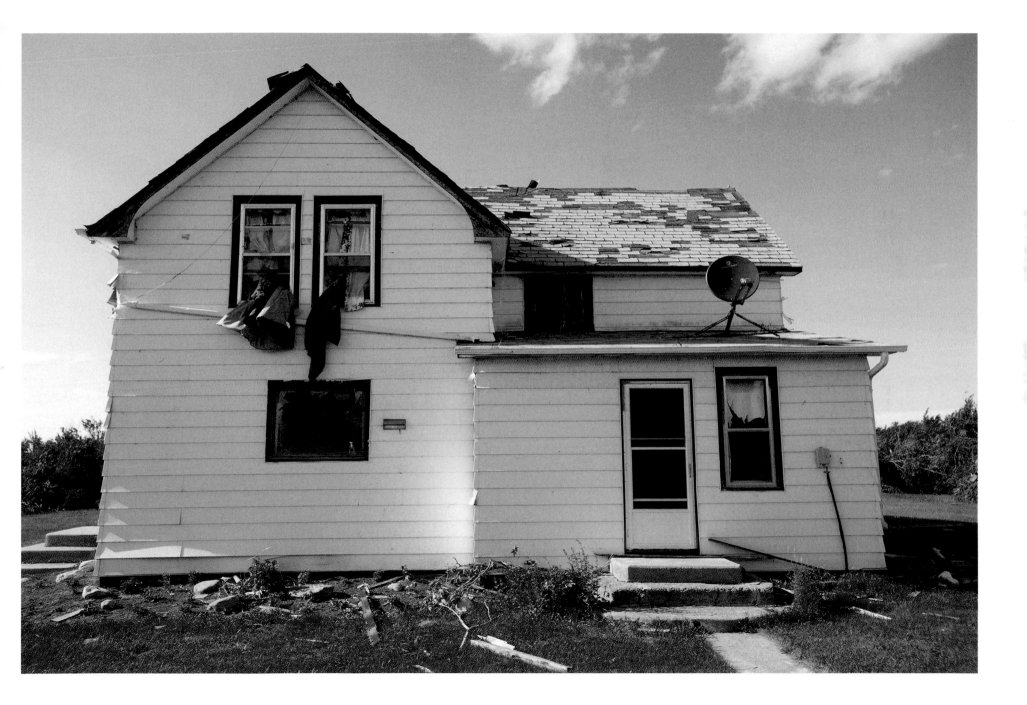

ABOVE High winds swept across Saskatoon in 2008, causing tumbleweeds to fill the yard of a local steel provider and completely cover the storage trailer.

(Richard Marjan/*Saskatoon StarPhoenix*)

FACING PAGE Chinooks—the warm, dry winds that occasionally blow down the east side of the Rocky Mountains—bring respite from winter weather in southern Alberta and Montana. The chinook's characteristic arch of clouds is seen in this photo of Calgary at sunset. (Leah Hennel/*Calgary Herald*)

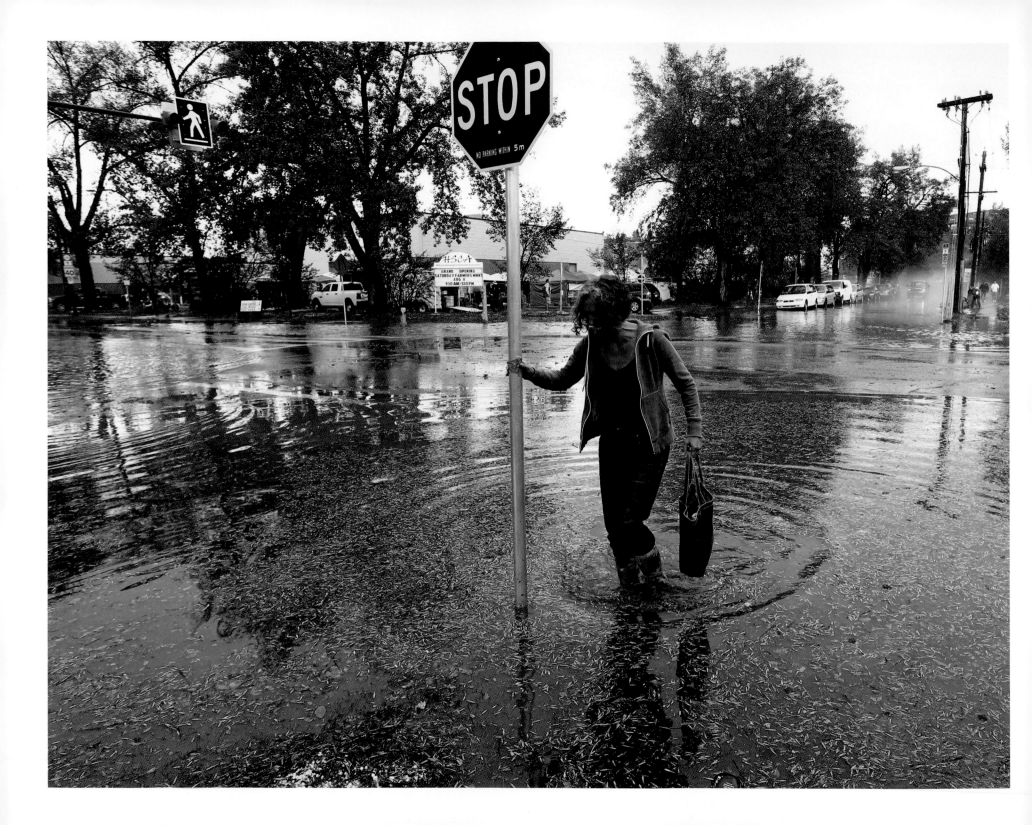

TWO

WATER

THE MOST FAMOUS flood in popular culture is described in the story of Noah. God wanted to cleanse the world of evil, so he instructed Noah to build an ark for his family and at least two of every type of living creature. Once all the animals were aboard, the rain fell for forty days and forty nights. Those aboard the ark were safe from the waters.

While it's rare for rain to fall for that long on the Prairies, there are certainly years when Prairie folks who live on flood plains may feel the urge to build an ark. Each spring and summer, these residents hold their breath to see just how high rivers will rise.

Nowhere are water levels watched more closely than on the Red River, which flows from its headwaters in North Dakota and Minnesota northwards into Manitoba. The river

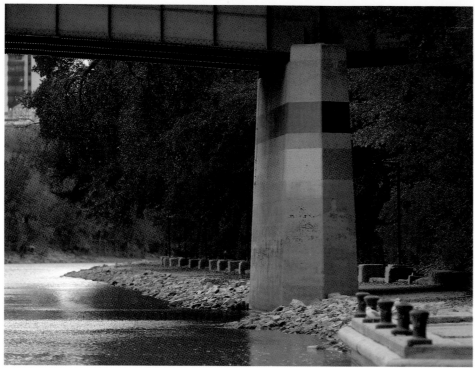

These painted stripes on the Midtown Bridge in Winnipeg indicate the level reached by the Red River during past major floods. The bottom blue stripe marks the water level reached in 1950; the middle yellow stripe represents 1852 and 1997 floods; and the top red stripe marks the height of floodwaters in 1826.

(Brian Donogh/*Winnipeg Sun*)

Prairie settlements continued to sprout along riverbanks, which meant flooding became a growing and sometimes deadly problem. A 1902 flood in Calgary saw four people die, including a six-year-old boy and his thirteen-year-old sister; both were killed when she tried to rescue him after he fell in the water.

Another set of tragic flood deaths occurred during a 1964 Montana disaster. Heavy rains caused a dam to collapse, killing thirty-one people, many of whom were children and most from the Blackfeet Reservation.

Some Prairie communities, including Edmonton, quickly learned how to manage flood-prone areas. The areas of the city lining the banks of the North Saskatchewan River were once bustling residential and business districts, but when waters rose eleven to twelve metres above usual levels in 1915, almost fifty houses and countless businesses were swept away. Another five hundred homes were partially or fully submerged. Hundreds of family members stood on the higher ground of nearby hillsides, some weeping and holding the few possessions they'd been able to gather before the rest of their worldly goods disappeared in the torrential waters. But after the flood was over, Edmonton dried itself off and began the process of rebuilding. Officials decided development on the river's banks should be

usually flows slowly and thus has never cut a deep path. It also moves across a glacial lakebed, which is quite flat and without much valley. The result is that when snow melts or heavy rains occur, floodwaters spread across vast areas.

When European settlers arrived here, they began keeping weather records that show one of the first recorded floods occurred in 1826. The river tore through the land at almost 6,400 cubic metres per second, killing at least a dozen Indigenous people and Fort Garry settlers. Survivors climbed onto rooftops and watched as the river swept away wagons, carts, furniture, food, building materials, and livestock. The difficult life of these early Prairie settlers had just become much more problematic, but they did what any persevering pioneer did: resettled, rebuilt, and moved forward.

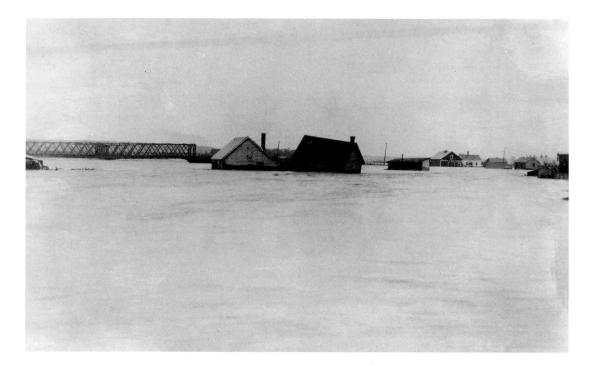

TOP Houses along the Bow River were immersed in floodwaters that also severely damaged the Langevin Bridge in Calgary in 1897.
(*Calgary Herald* archives)

BOTTOM LEFT This photo shows submerged structures in Fargo, North Dakota, during an 1897 flood.
(North Dakota Studies Program)

BOTTOM RIGHT A man named Mr. Birnie used a rowboat to help Calgarians move around the community after the 1902 flood.
(*Calgary Herald* archives)

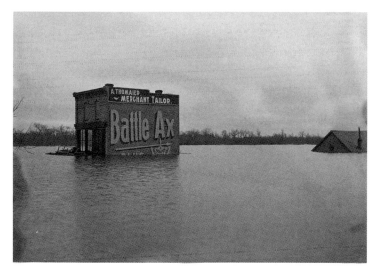

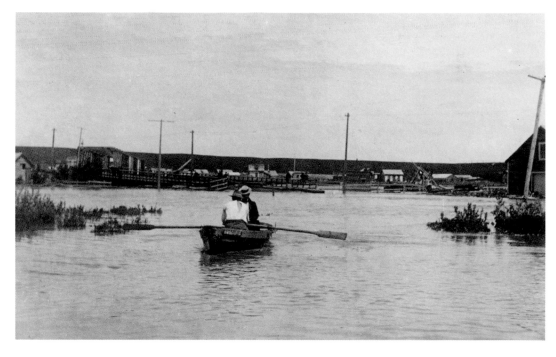

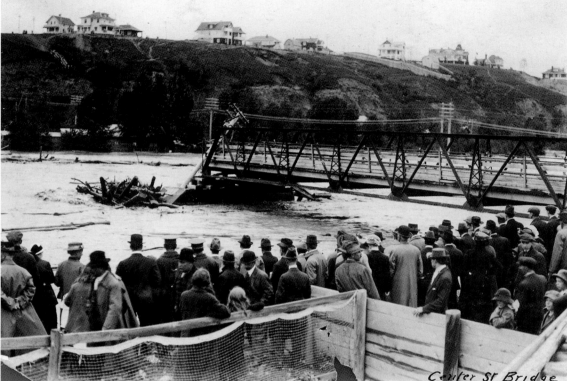

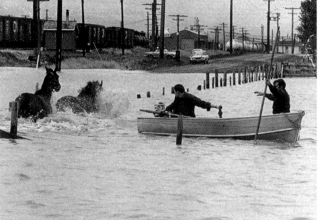

Center St Bridge

discouraged, to help prevent future flooding of property. This also allowed the river valley to become a noteworthy natural green space that is still the envy of many North American communities today.

Manitoba, too, has always had a healthy respect for angry rivers, especially after a 1950 deluge led the Red River to crest 9.2 metres above normal levels and cause $125 million in damages. Afterwards, the province began plans for construction of the Red River Floodway. Finished in 1968, it now diverts water around Winnipeg when rivers rise too high. It's been used more than twenty times and has saved tens of billions of dollars in flood damage over the years.

TOP LEFT Flooding in Calgary in 1915 caused two deaths, including a man who was on his way to work via the Centre Street Bridge (pictured here), when parts of it were swept away. (*Calgary Herald* archives)

TOP RIGHT Spring rains caused flooding in several communities in Alberta at least four times in the mid-1900s. Here, Ernest Beisel worked to rescue two horses after his small farm southeast of Calgary turned into a lake. (*Calgary Herald* archives)

FACING PAGE A train was moved onto Edmonton's Low Level Bridge to help prevent it from being washed away during flooding in 1915.

(*Edmonton Journal* archives)

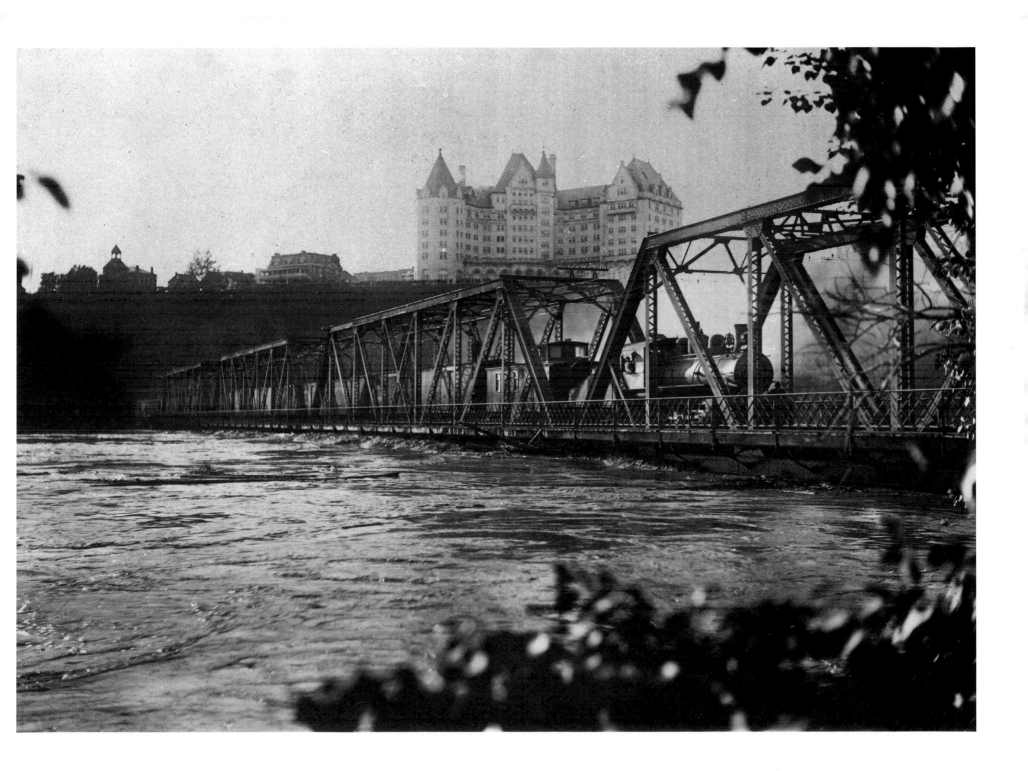

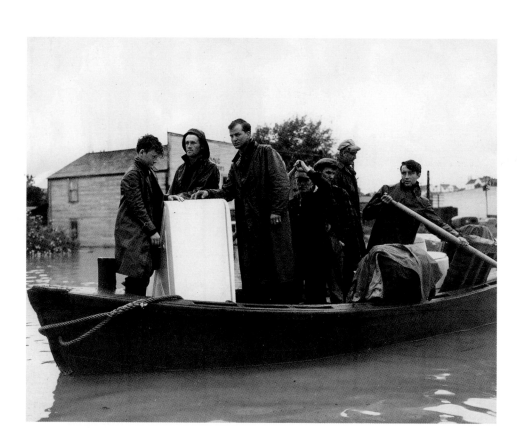

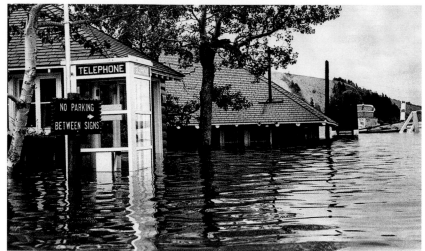

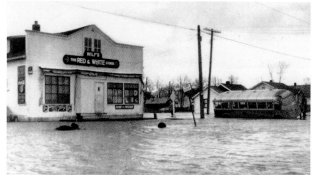

When flooding does occur on the Prairies, one common thread that winds its way through almost every narrative is that of community. People stand shoulder to shoulder, helping neighbours and strangers, as was the case in southern Saskatchewan in 1974. Major evacuations occurred in Regina, Moose Jaw, and the town of Lumsden, where a dike broke. Hundreds of people poured into Lumsden to build a massive temporary replacement dike; students were given time off school to help fill sandbags. Men from all walks of life in Regina drove to the town to help locals move dirt. Private

LEFT In Calgary in 1948, residents along the Elbow River fled surging waters. The Navy aided in the evacuation of residents, including one who brought along a valuable household possession— a refrigerator. (*Calgary Herald* archives)

TOP RIGHT Floods plagued Alberta and Montana in 1964, including Waterton, near the Canada-U.S. border.

(*Calgary Herald* archives)

BOTTOM RIGHT The 1950 flooding of the Red River was called Canada's worst flood for several decades. (*Winnipeg Sun* archives)

FACING PAGE An aerial shot of the Riverview section of Winnipeg showed some of the deluge that inundated the city in 1950. (Postmedia archives)

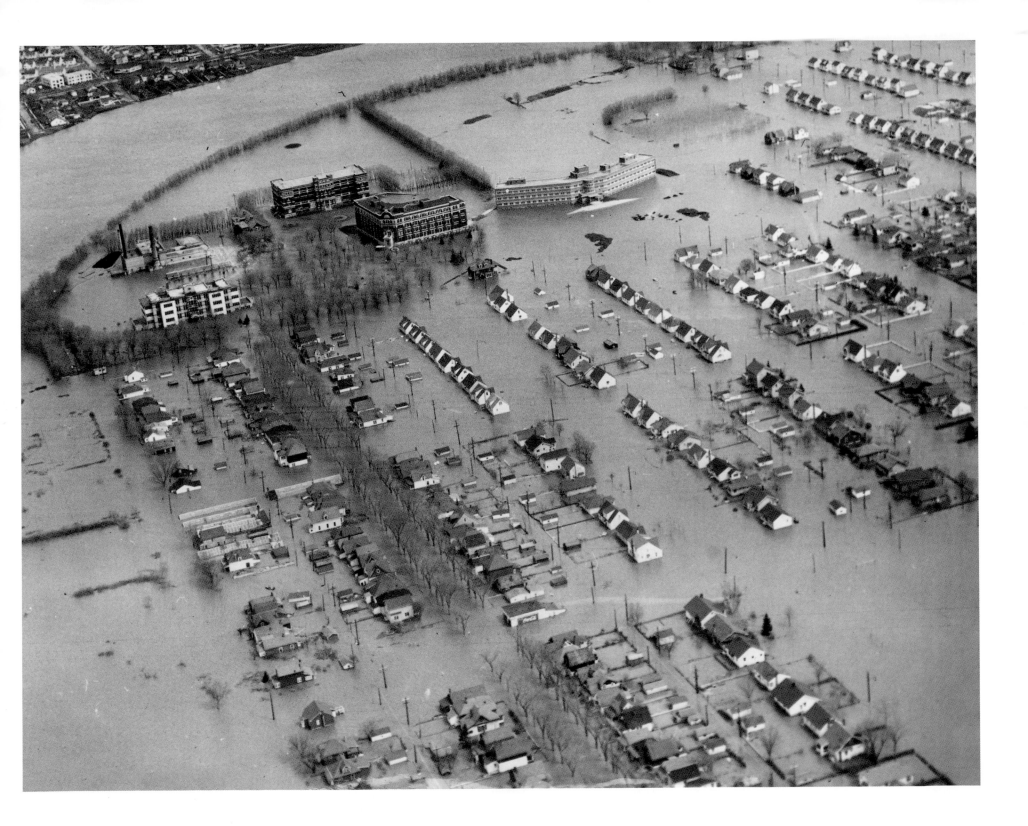

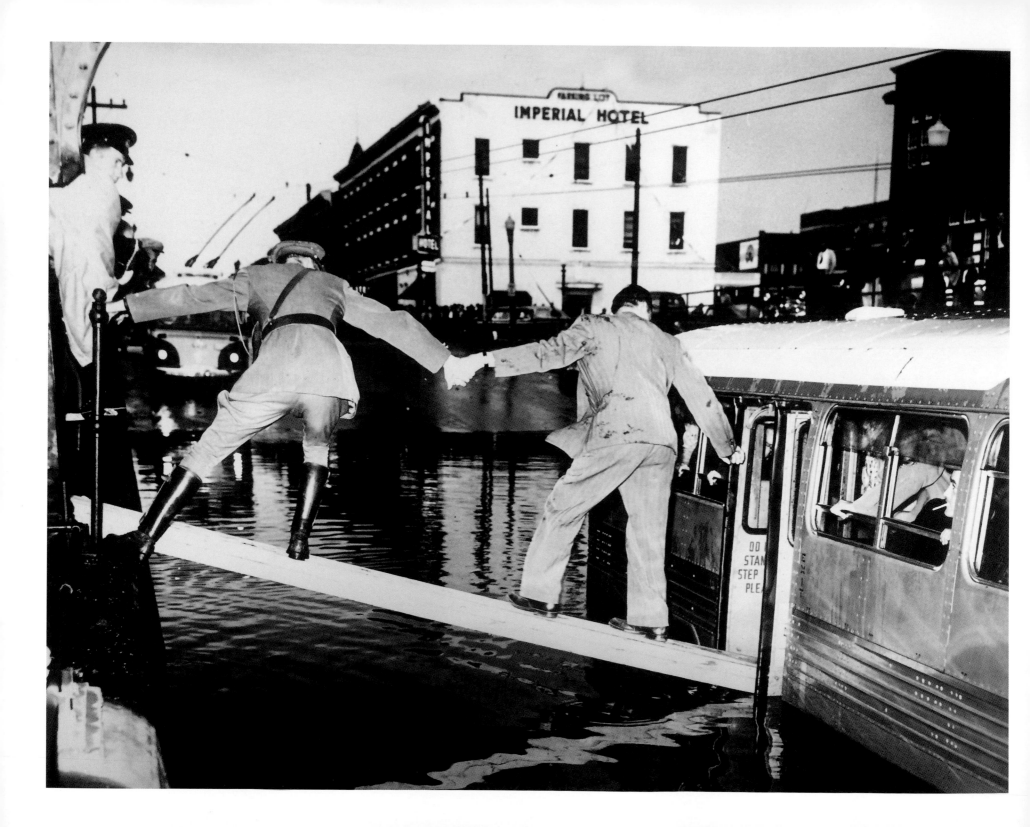

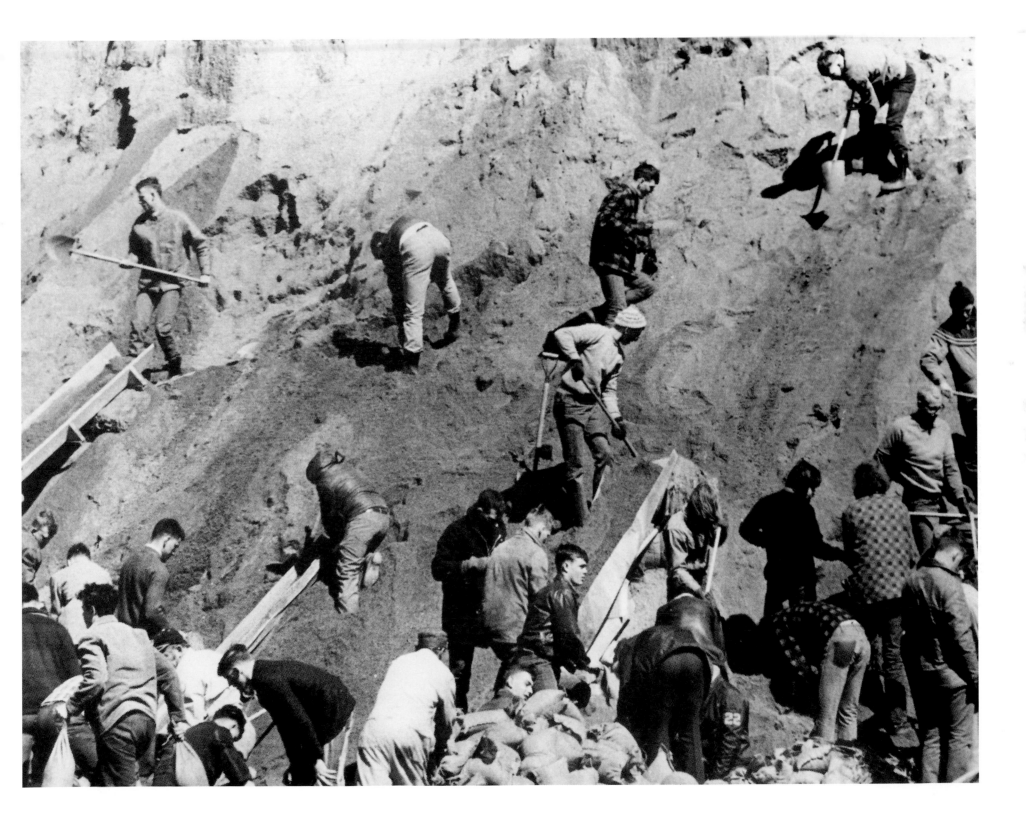

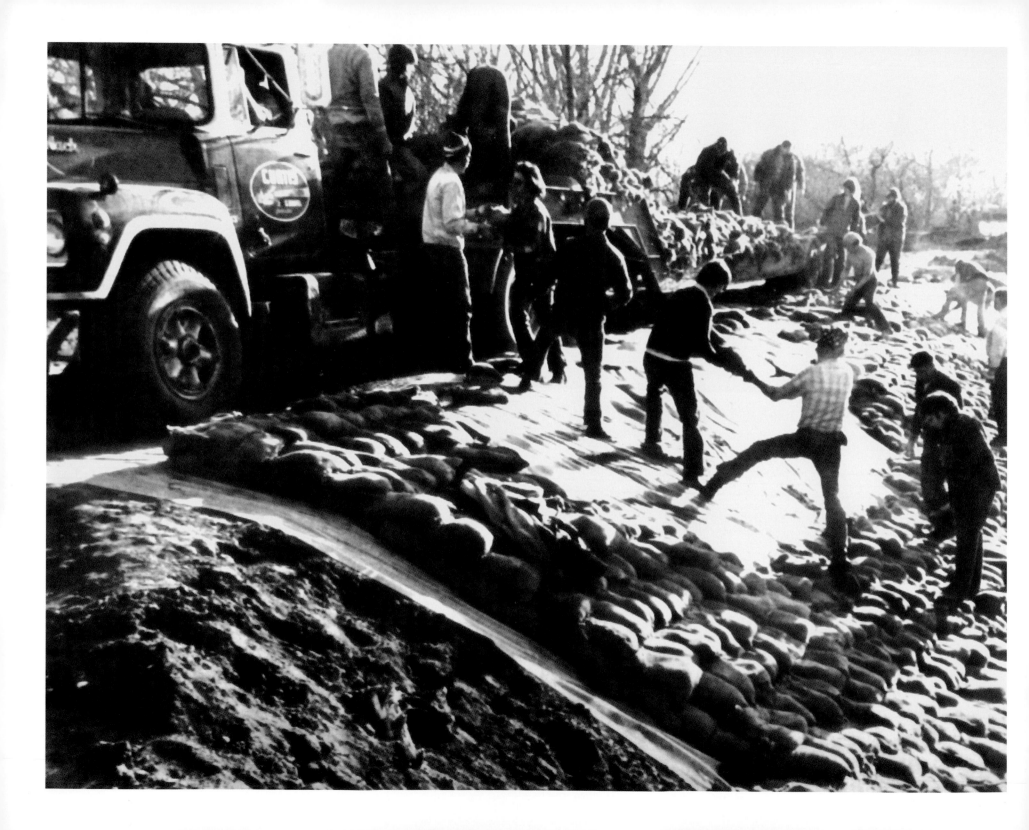

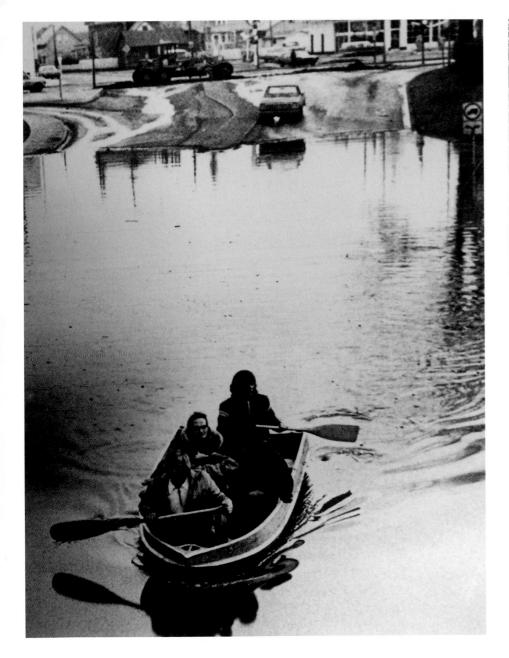

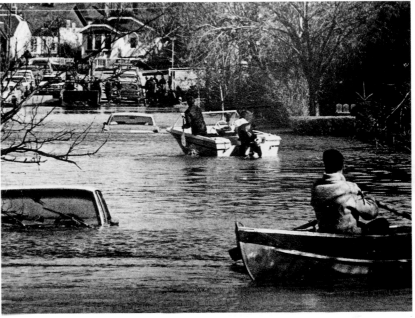

PREVIOUS SPREAD LEFT A fierce rainstorm in 1951 flooded several streets in Calgary; police helped rescue people trapped in cars and buses. (*Calgary Herald* archives)

PREVIOUS SPREAD RIGHT Volunteers filled tens of thousands of sandbags after an Easter Sunday deluge hit Regina in 1971. (*Regina Leader-Post* archives)

FACING PAGE In 1974 in Lumsden (just northwest of Regina), workers and volunteers successfully built a contingency dike, up to 6 metres high and 5 kilometres long, to save the town from a flood disaster. The dike became known as the "Great Wall of Lumsden." (*Regina Leader-Post* archives)

LEFT Flooding took its toll on Moose Jaw in 1974, when swollen rivers and creeks led to 80 percent of homes being evacuated; 480 were eventually surrounded by water or even submerged up to the rooftops. (*Regina Leader-Post* archives)

ABOVE Canoes and boats appeared on streets that turned into lakes during the 1971 flood in Regina. (*Regina Leader-Post* archives)

TOP RIGHT A March 1997 flood forced dozens of people to temporarily abandon their homes in Swift Current, Saskatchewan.

(Bryan Schlosser/*Regina Leader-Post*)

BOTTOM RIGHT A flood worker delivers sandbags in the community of Grande Pointe, Manitoba (just southeast of Winnipeg), in the 1997 "flood of the century" of the Red River.

(Colleen De Neve/*Calgary Herald*)

FACING PAGE Anne-Marie and Robert Filion stand in front of their Manitoba farmhouse, near St. Jean Baptiste, where they constructed a dike of straw, sheet metal, wood, and sandbags to battle the 1997 flood of the Red River.

(Postmedia archives)

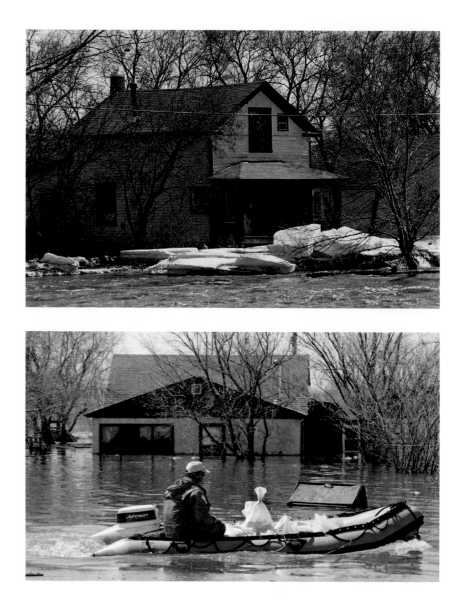

construction firms donated earthmovers, dump trucks, graders, and backhoes. Together, they feverishly erected the "Great Wall of Lumsden," a five-kilometre-long makeshift dike of dirt and sandbags reaching up to six metres in height and reinforced with old, crushed car bodies. The river's flow eventually reached five times its normal speed, but the volunteers' efforts saved the town.

That type of extraordinary achievement was also seen during two more recent floods to hit the Prairies. The first was the 1997 "flood of the century"—caused by the most severe deluge in Manitoba since 1852—which saw the Red River surge twelve metres higher than its winter level. The bedlam started in the neighbouring communities of Grand Forks, North Dakota, and East Grand Forks, Minnesota, where almost all residents were evacuated. Not only were these communities flooded, but the water also shorted out an electrical system, leading to a fire that destroyed several Grand Forks buildings. Ultimately, damages for these two states rose to more than US$2 billion.

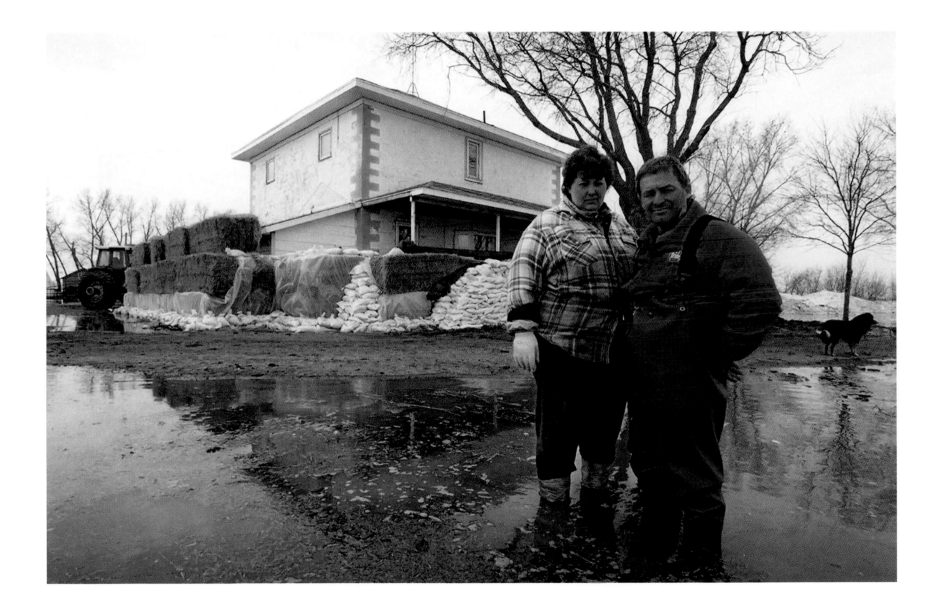

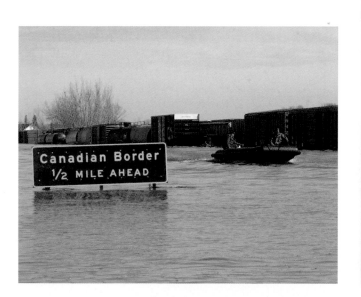

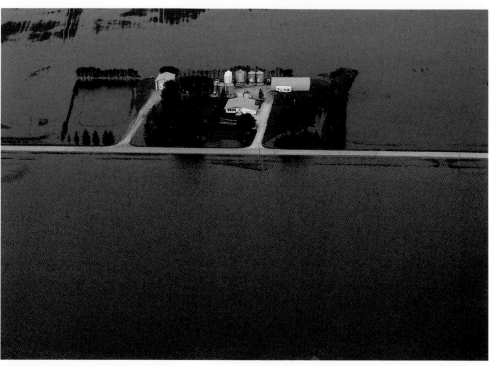

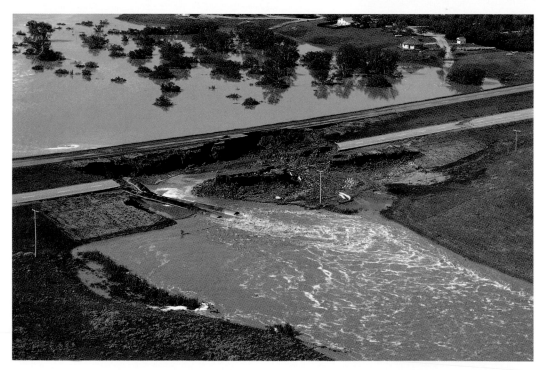

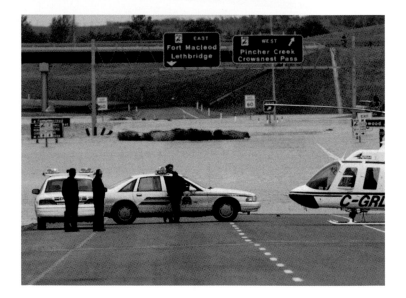

FACING PAGE TOP LEFT An assault craft patrolled a flooded area in Manitoba near the American border during the 1997 deluge. (*Postmedia* archives)

FACING PAGE BOTTOM LEFT Parts of the Trans-Canada Highway, just west of Maple Creek, were destroyed by a 2010 storm that belted the southwest corner of Saskatchewan. (*Troy Fleece/Regina Leader-Post*)

FACING PAGE TOP RIGHT Torrential rain in Manitoba in June and July 2005 led to two dozen towns declaring states of emergency due to flooding. (*Winnipeg Sun* archives)

FACING PAGE BOTTOM RIGHT A herd of cattle trying to escape flooding in southern Alberta in 1995 eventually became surrounded by the water on a road near Fort Macleod, 175 kilometres south of Calgary. They were later rescued. (*Calgary Herald* archives)

RIGHT In Medicine Hat, Henry Benbow rescued a fawn from the swollen waters of the South Saskatchewan River during flooding in 2005. (*Calgary Herald* archives)

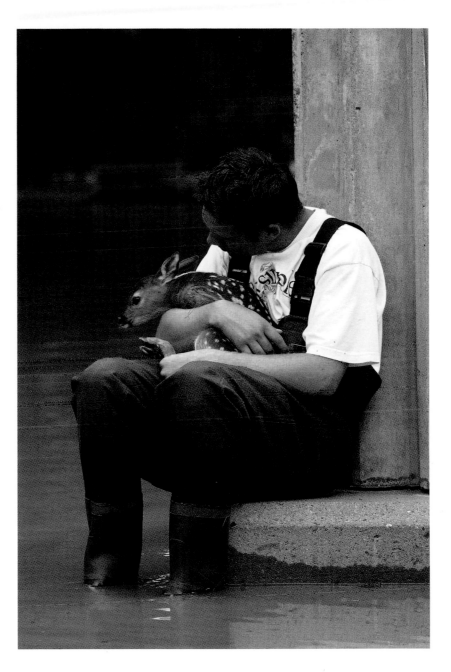

Seeing the destruction in the U.S., Manitoba began a frenzied race to reinforce dikes around homes and communities while also digging an emergency dike west of Winnipeg in just three days. The treacherous floodwaters hit Manitoba on April 29, eventually submerging about 2,000 square kilometres of land and resulting in more than $400 million in damage. But the work by seventy thousand volunteers and seven thousand soldiers who battled the waters for days was a testament to the strength of the human spirit. They didn't give up their fight against the river.

The second recent flood that rallied Prairie folk to pitch in was the 2013 deluge in southern Alberta. The unrelenting flood began on June 20, as rivers and creeks surged over their banks and tore through towns, cities, ranches, and farms. More than 100,000 people fled to higher ground, including tens of thousands in the city of Calgary.

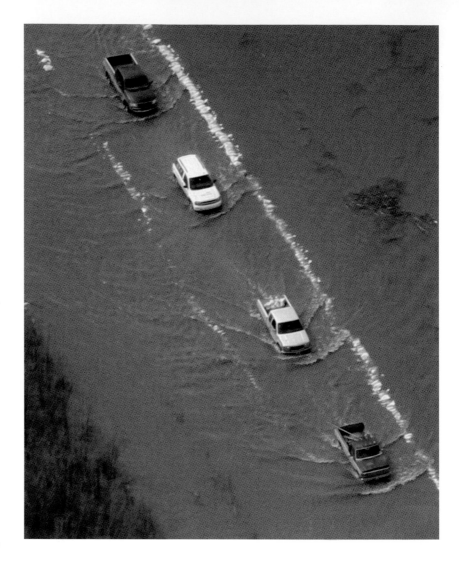

Tragically, five people were killed in the flood, including Rob Nelson—a forty-one-year-old father of six, who died while driving a quad that he was using to shuttle people through mud and water. Another of the flood's heroes was Jacqui Brocklebank—a thirty-three-year-old with cerebral palsy who helped a friend escape her basement suite. As torrents rushed past them in the street, an errant trailer knocked Brocklebank into the water. She didn't survive.

Brocklebank's death occurred in High River, a town of 13,000 that was devastated by the flood. Half the town was under water, with the Highwood River flowing faster than the water flows at Niagara Falls.

The resiliency of the people of High River became legendary, as did the grit and determination shown by many others across the province. Countless fundraisers occurred, including a massive Flood Aid concert. The Calgary Foundation established a flood-rebuilding fund, which ultimately collected $9.1 million for 131 flood-related charitable projects. Millions more were distributed via government channels and the Red Cross.

With $6 billion in damages and recovery costs, the 2013 flood became the costliest Canadian disaster for insurance companies at the time. Years after the flood, repair work continues.

"This has been quite tragic for a lot of people," said astronaut Chris Hadfield, who was in Alberta in the flood's aftermath as parade marshal for the Calgary Stampede. "But at the same time people endure ... what really matters are the people and how we help each other."

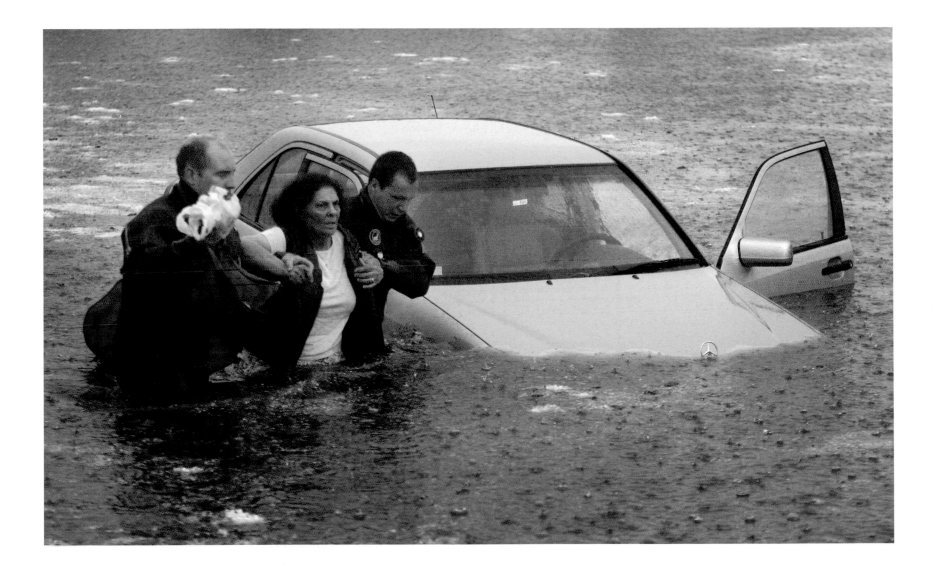

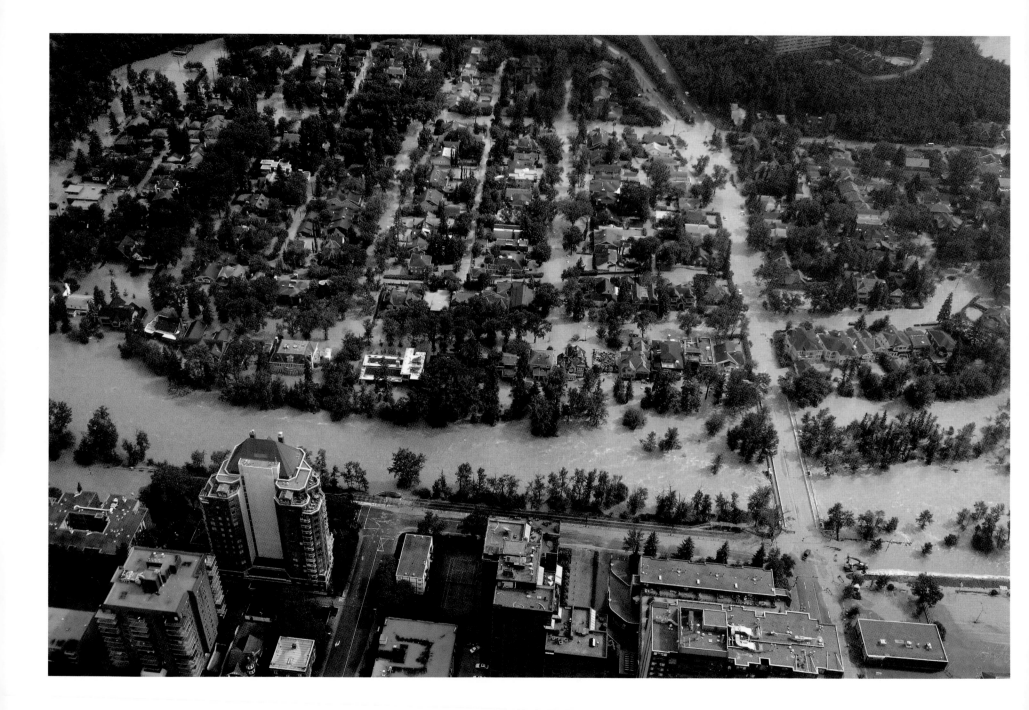

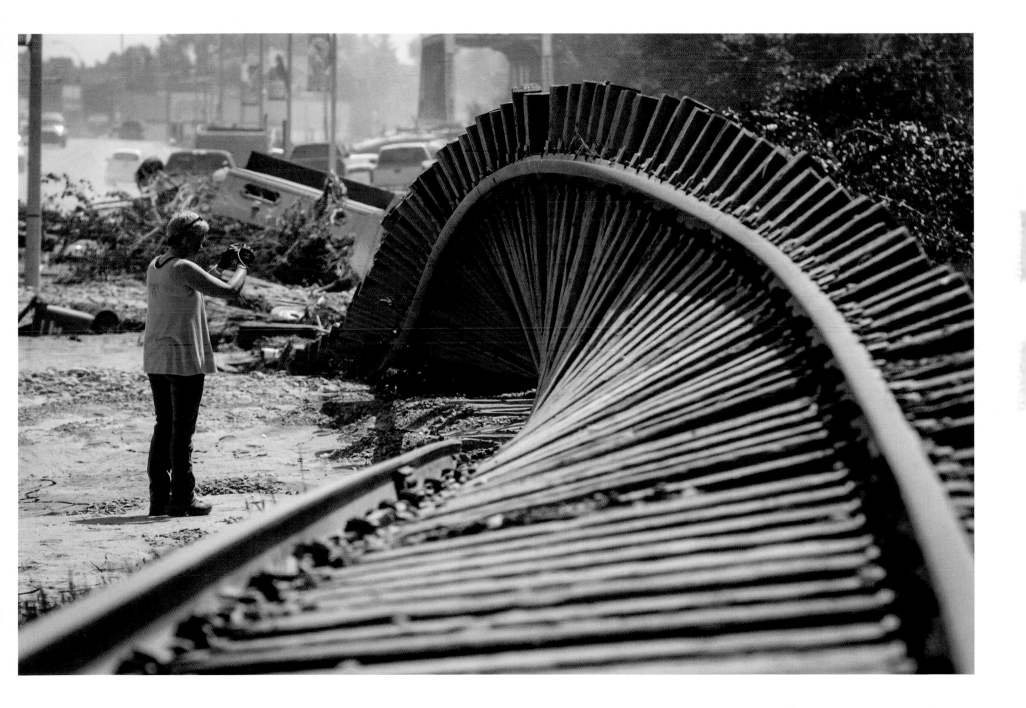

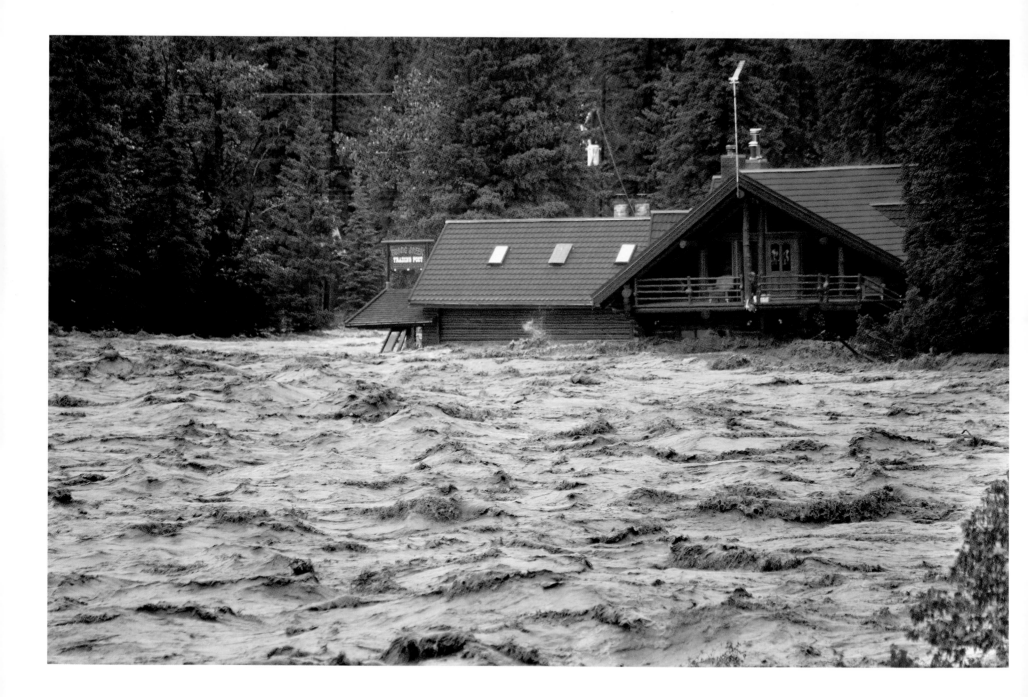

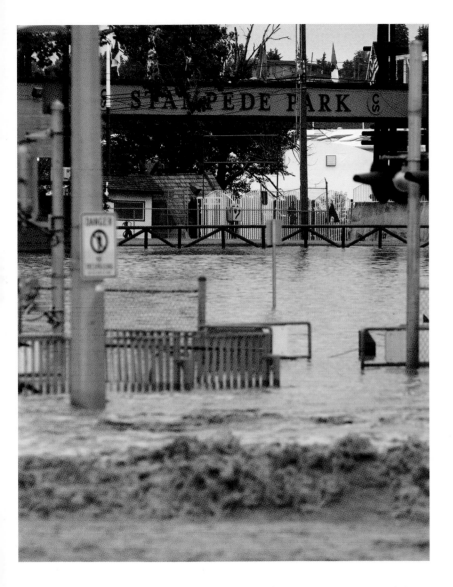

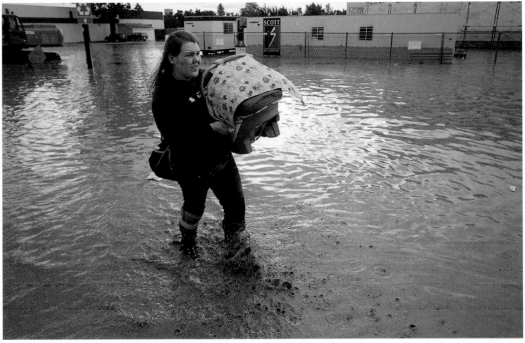

PREVIOUS SPREAD LEFT This aerial shot shows a portion of Calgary that was flooded in 2013, leading to the evacuation of more than 100,000 people in southern Alberta. (Ted Rhodes/*Calgary Herald*)

PREVIOUS SPREAD RIGHT A woman in High River, 65 kilometres south of Calgary, took a photo of train tracks that were twisted by the torrential waters.

(Lyle Aspinall/*Calgary Sun*)

FACING PAGE Flood waters of the Elbow River tore into a home in Bragg Creek, just outside of Calgary. (Mike Drew/*Calgary Sun*)

LEFT The flood heavily damaged Calgary's Stampede Park just two weeks before the annual event, but a Herculean clean-up and repair effort allowed the Stampede to open on time.

(Gavin Young/*Calgary Herald*)

ABOVE A woman in High River carried her infant to safety, as waters began to flood the parking lot where she'd left her vehicle while doing morning errands.

(*Calgary Herald* archives)

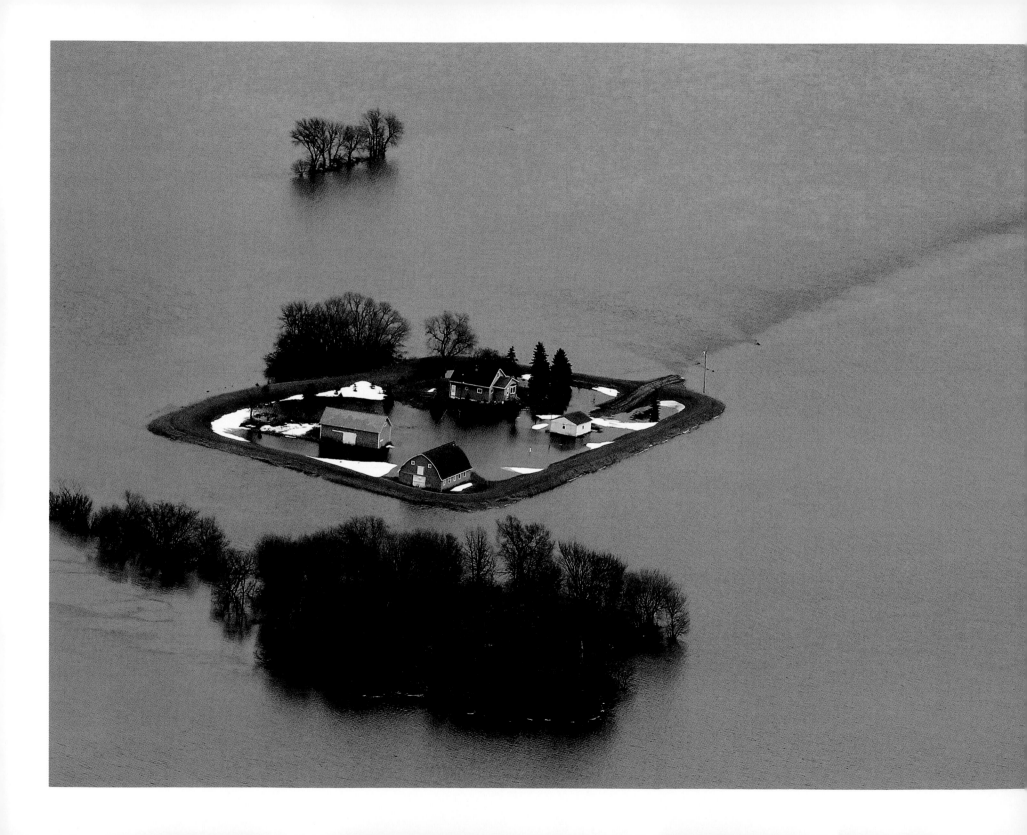

LEFT This North Dakota farm, near Fargo, was isolated by flooding in 2010, which reached slightly lower levels than those of the 2009 devastating flood.

(Scott Olson/Getty Images, Postmedia archives)

ABOVE Water from the Red River flooded many parts of North Dakota in 2010.

(Scott Olson/Getty Images, Postmedia archives)

OVERLEAF LEFT The 2014 floods left many communities under water, including Crooked Lake, Saskatchewan, 170 kilometres east of Regina.

(Don Healy/*Regina Leader-Post*)

OVERLEAF RIGHT June storms led to the flooding of this Saskatoon park in 2010.

(Gord Waldner/*Saskatoon StarPhoenix*)

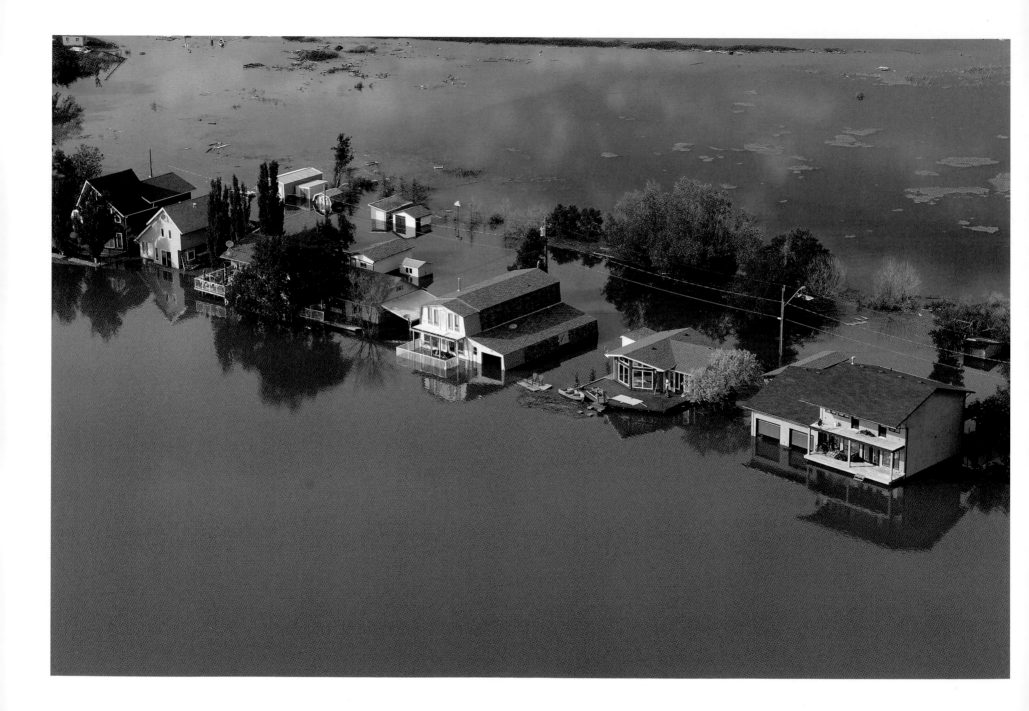

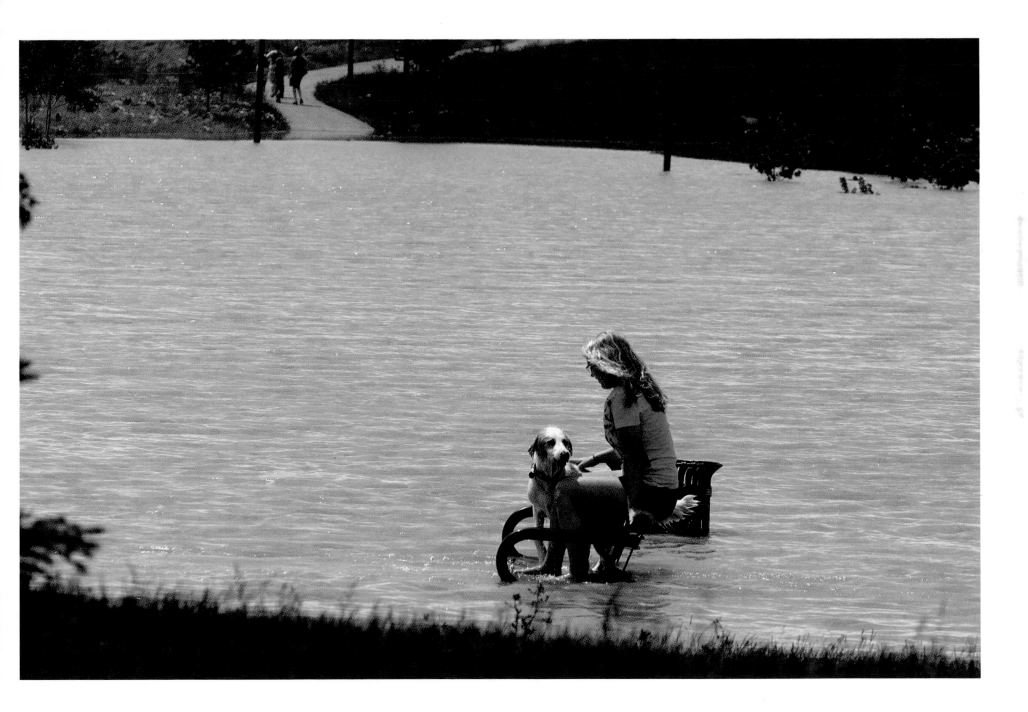

FACING PAGE An icy Winnipeg hill
provided the perfect sledding venue for
Tom Hao and sons Nick and Andy in 2014.
(Brian Donogh/*Winnipeg Sun*)

THREE

ICE

ERHAPS NO ASPECT of the weather defines the Prairies more than ice. Hail and snow—both forms of ice—are said to represent the meeting of heaven and earth. Icy conditions can paint a breathtakingly beautiful picture, but can also result in wild weather that can be difficult to survive.

At their most extreme, blasts of snow and ice can kill. This is especially true when storms are unexpected, as was the Schoolhouse Blizzard of 1888. In that year, a snowstorm caught tens of thousands of people by surprise on what had been a mild January day. Many residents in the states of Montana, North Dakota, and Minnesota were

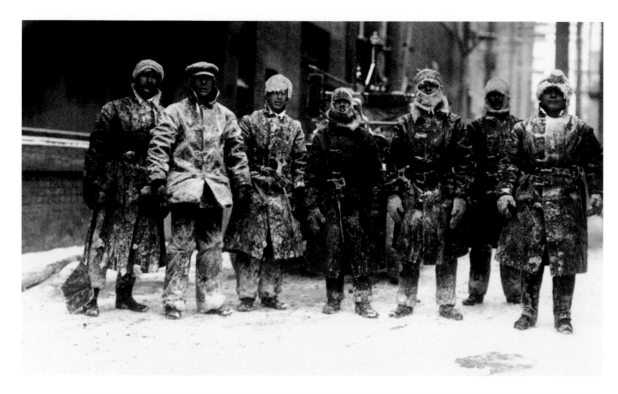

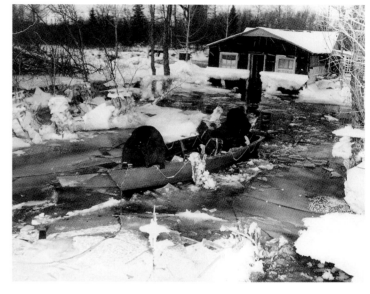

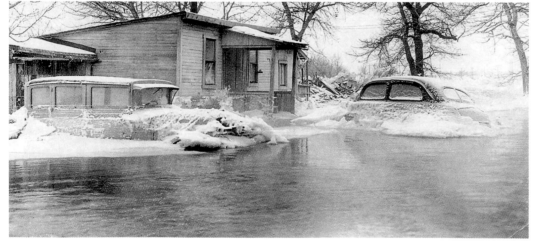

TOP LEFT Calgary's fire department battled snow and ice, along with flames, during a liquor store fire in 1916. (*Calgary Herald* archives)

BOTTOM LEFT Freezing water ruined homes and vehicles when Bow River ice jams wreaked havoc in Calgary in 1953. (*Calgary Herald* archives)

ABOVE A December 1946 ice jam and flood took the life of Gordon Grassick, who died while rescuing his wife and daughter from high waters invading their cottage. Pictured here, Grassick's brother (in the rear of the boat) and a Calgary firefighter retrieved family belongings. (*Calgary Herald* archives)

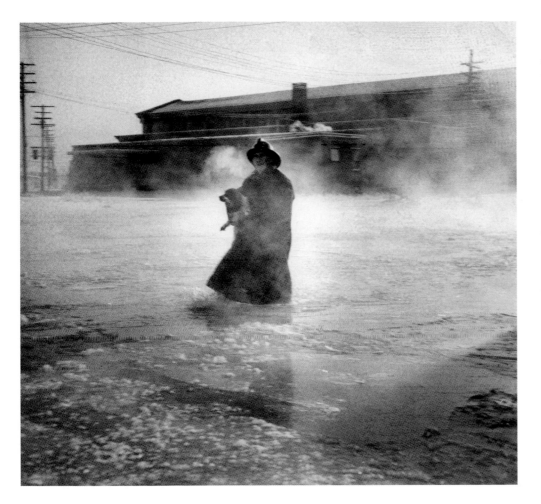

A 1954 ice jam and flood led to an evacuation of Calgary's dog pound. Most of the twenty dogs in the pound were transported to dry land and set free. Here, a firefighter helps one dog to safety.

(*Calgary Herald* archives)

and North Dakota in 1920 killed thirty-four people; the death toll again included children attempting to walk home from school. During a 1941 blizzard, also in North Dakota and Saskatchewan, more than thirty people died, most of whom were trapped in their cars by the blinding snowstorm; another thirty-two perished in Minnesota.

The storm of 1947, however, was one for the record books and became known as the "worst blizzard in Canadian railway history," according to Environment Canada. Not only did it bury cities, towns, and farms across the Prairies; it also dumped so much snow on rail lines that trains from Winnipeg to Calgary remained stalled in massive snowdrifts until spring.

Snow disrupted almost every aspect of Prairie people's lives that year. Across the Great Plains, there was so much snow that students built tunnels between their rural schools and the outhouses while farmers dug passageways between their homes and barns. Many towns ran out of crucial supplies such as milk. The *Regina Leader-Post* said the blizzard became so dangerous that some churches and businesses closed and encouraged people to stay at home, where it was safe. The blizzard was also

stranded, especially in rural schoolhouses, which gave rise to the storm's name. Hundreds of people who ventured outside suffered frostbite and other injuries. Another 235 lost their lives to the storm, including many children who tried to make it home from school.

Tragically, deadly blizzards weren't uncommon on the Great Plains in the late 1800s and early 1900s. A storm in Saskatchewan

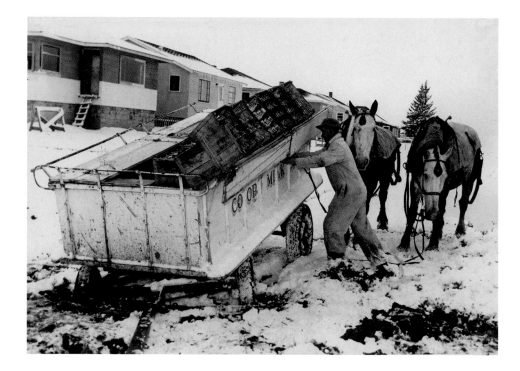

ABOVE A 1951 snowstorm left Calgary roads a mess, making passage almost impossible for all, including this horse-drawn milk cart. (*Calgary Herald* archives)

FACING PAGE LEFT A blizzard across the Prairie provinces in 1961 was so severe that it even stopped trains. (Postmedia archives)

FACING PAGE RIGHT A 1950 snowstorm kept some trains, such as these railcars in Alberta, buried for months on the Great Plains. (Postmedia archives)

hard on livestock. One farmer lost cattle to the storm after they began stampeding when the storm hit. Another farmer's dairy barn was completely buried by snow, so he ripped a hole in the barn's roof to get to the cows so he could milk them.

More than any other weather phenomenon, livestock was particularly vulnerable to icy storms. More than 130,000 hogs, sheep, and cattle were killed by a 1966 wintry blast in Manitoba and North Dakota. Some of the animals were in barns that collapsed due to the accumulated weight of the snow. Others suffocated in barns that had become firmly sealed under massive snowdrifts; oxygen couldn't properly circulate inside.

During that 1966 storm, winds gusted from 100 to 160 kilometres per hour. Snowdrifts grew up to nine metres in height. Roads were closed and many people were trapped in their vehicles. Two of the eighteen deaths attributed to the storm were young girls in North Dakota who walked from their farmhouse to the barn to check on livestock. But upon exiting the barn, they became disoriented due to the blinding snowstorm and wandered into a pasture where they perished.

The storm was so hard on Winnipeg that the blizzard earned the title of "snowstorm of the century" in the city at the time. All

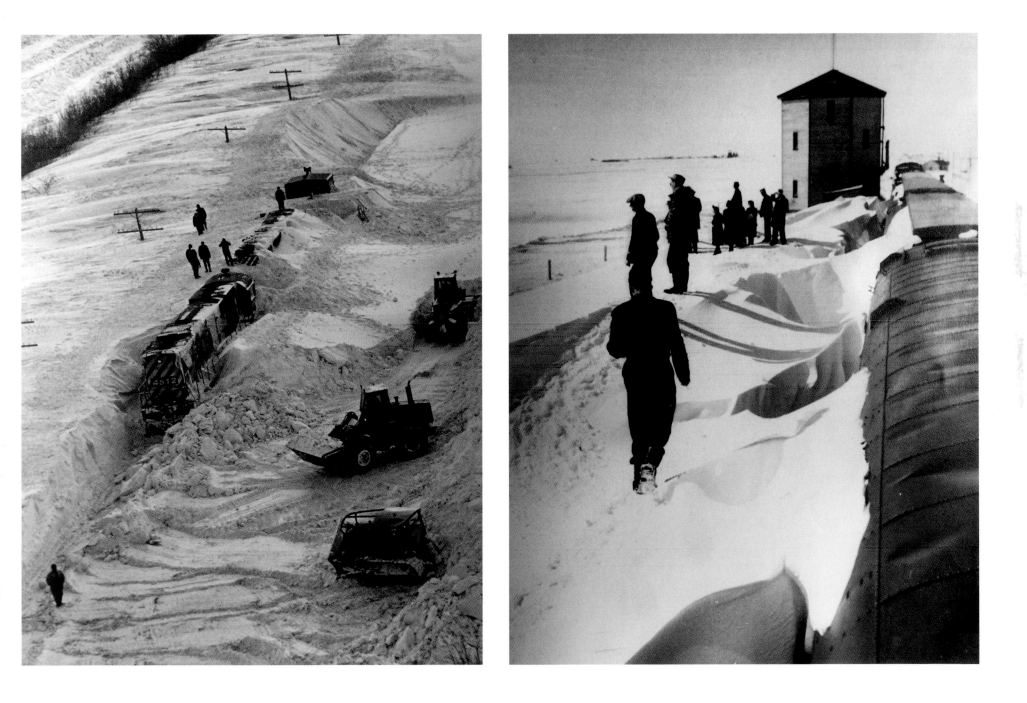

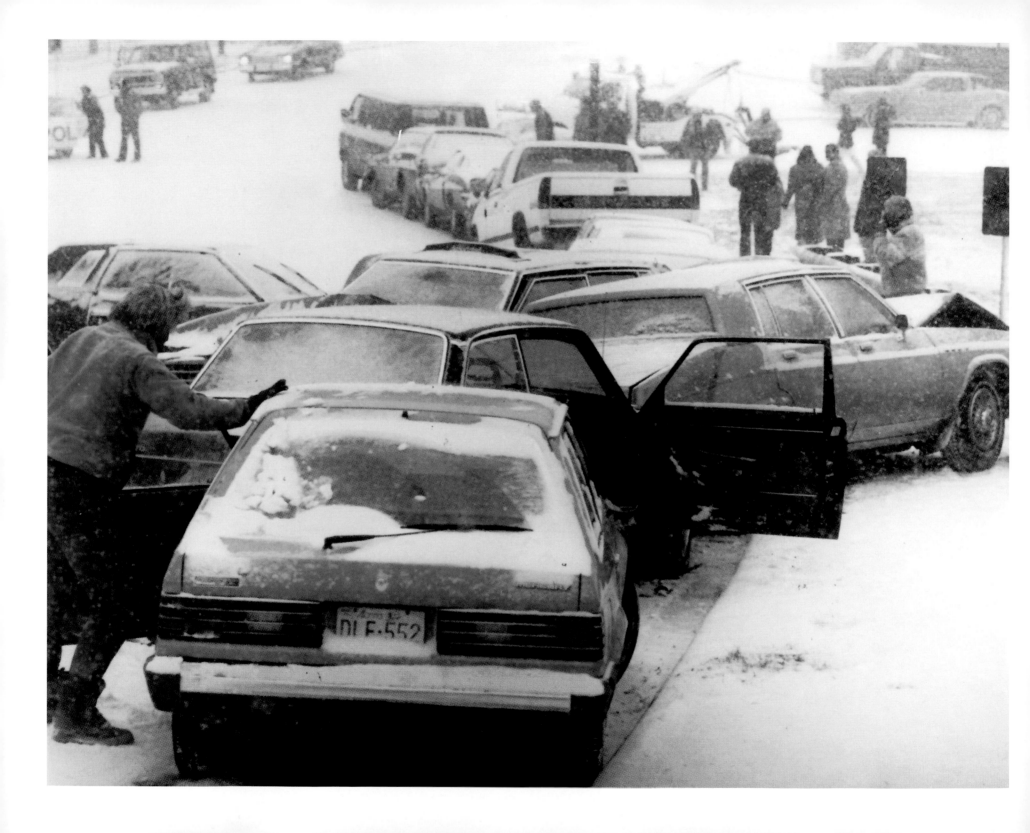

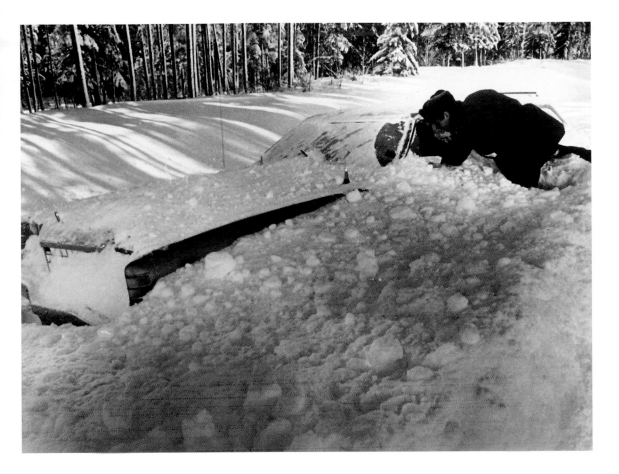

BELOW Blowing snow, high winds, and icy roads led to this forty-vehicle pile-up in Calgary a few days before Christmas in 1996. (*Calgary Herald* archives)

FACING PAGE Each year, almost one out of every three accidents in Canada involves snowy or icy road conditions, like those that caused this November 1987 chain-reaction crash in Calgary.
(*Calgary Herald* archives)

ABOVE After rural blizzards, the RCMP routinely check cars stuck in the snow to ensure there aren't people stranded inside. Here, RCMP Const. J.A. Hobbell assessed a vehicle on the Trans-Canada Highway in 1979. (Postmedia archives)

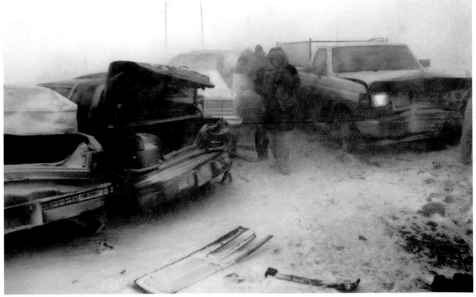

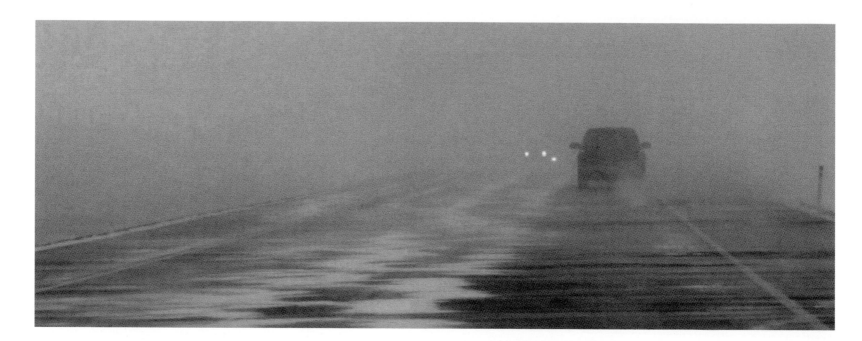

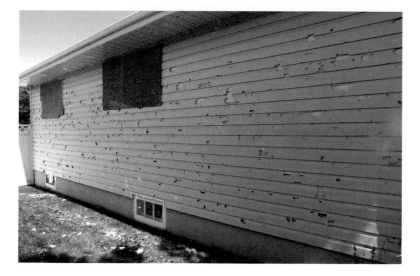

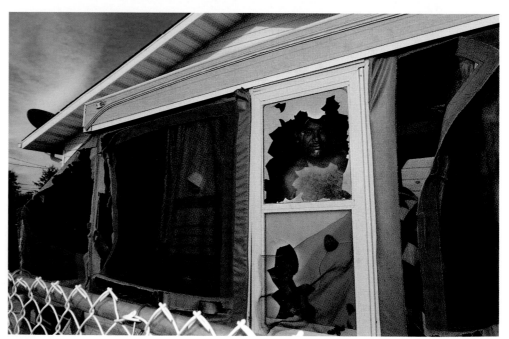

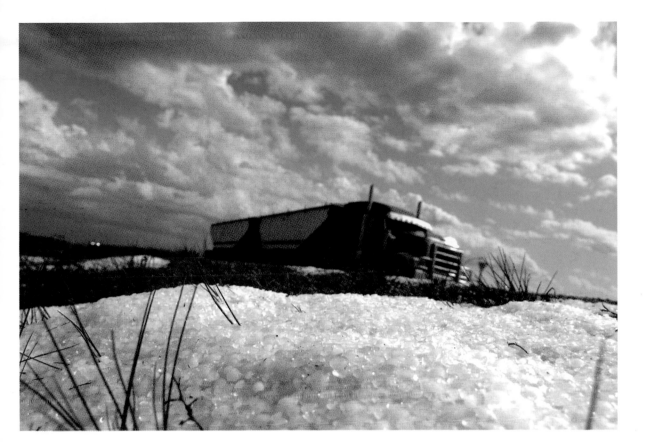

highways were blocked, all air travel was halted, and the mayor told everyone to stay at home until the blizzard was over.

Another severe series of blizzards occurred in southern Alberta in April 1967, resulting in the Army being called to help. The snow was so deep that cattle couldn't forage for food and thousands died. But army helicopters were able to save thousands more by dropping hay on snow-covered rangeland. The American air force, based in Montana, assisted with what was named Operation Snowbound to save Alberta's cattle.

Snow isn't the only frozen precipitation that falls on the Prairies. During the summer, strong winds can push raindrops upwards into cold air, where they freeze into hailstones. When hailstorms occur, damage can be substantial. It's no wonder that a "thunderstorm" of hail was one of the famous ten biblical plagues of Egypt.

Reports of perilous hail on the Great Plains date back to the 1800s. For example, the community of Ellisboro, Saskatchewan, east of Regina, was walloped by a heavy rain- and hailstorm in 1895, with hailstones reported as being as large as baseballs.

In another infamous storm, a combination of ice, wind, and lightning struck Gravelbourg and Lafleche in south central Saskatchewan in 1924. A thick blanket of hail covered wide swaths of land. The hail was 5 centimetres deep, covering an area 8 kilometres

long and 33 kilometres wide. At the same time that hail was accumulating, a cyclone also struck the area, lifting up one house and carrying it more than 350 metres before dropping it and turning it into "a heap of splintered wood," the *Morning Leader* in Regina reported. One man was killed in the storm; he was struck by a fiery bolt of lightning while carrying a pail of milk from the barn to his house. The man's wife said the lightning lifted him about two metres into the air, ripping his shoes and clothes from his body.

Piles of icy hail were also a noteworthy characteristic of a May 30, 1961, storm in Buffalo Gap, Saskatchewan, just north of the American border. In addition to the hail, about 254 millimetres—the equivalent of an entire year's worth of rain—fell in one hour and flooded the community, making it the greatest flash flood on record in Canadian history, Environment Canada said. The hail, however, was so remarkable that a local grain elevator operator reported that it piled up more than a metre deep, covering fences and giving the community the appearance of a harsh, winter landscape. The operator noted that as he dashed for shelter, he was pelted by so much golf-ball-sized hail that he suffered more than fifty bruises on his legs.

One of the worst parts of the planet for hail damage each year, however, is the south and central region of Alberta, nicknamed Hailstorm Alley. A September 1991 hailstorm in Calgary, for example, cracked windows, tore apart the siding of houses, damaged roofs, dented thousands of cars, and cost insurers $343 million—the most destructive hailstorm to strike Canada at the time.

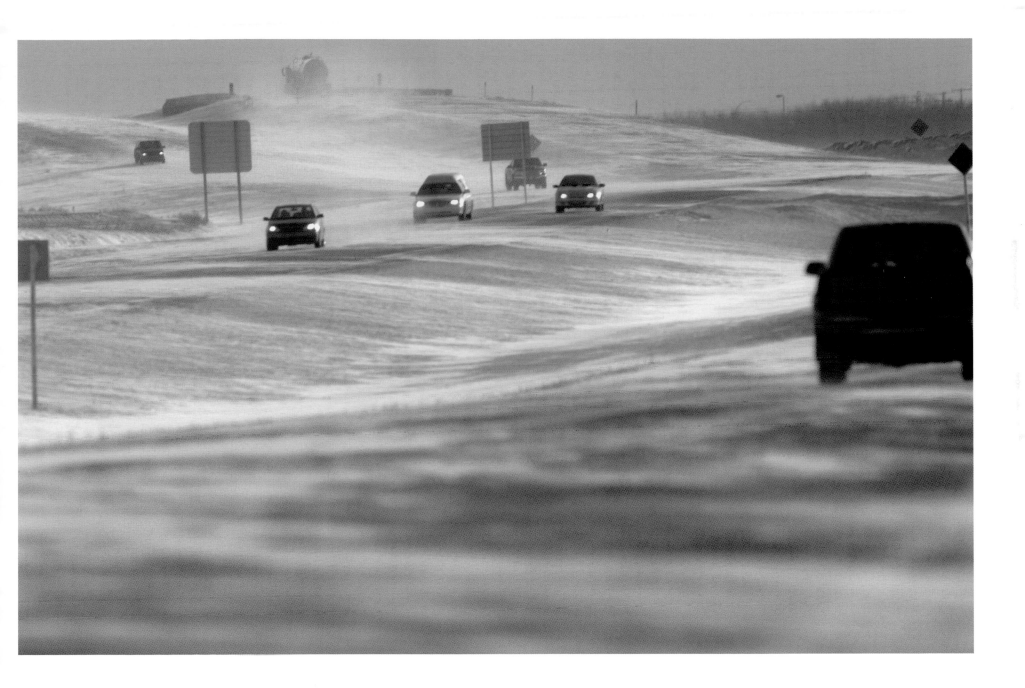

A similar storm in Calgary in July 1996 with hail the size of oranges led to almost $300 million in costs. A 2010 hailstorm in the area caused $530 million in damages. And in August 2014, the community of Airdrie, just north of Calgary, was pummelled by golf-ball-sized hailstones, resulting in more than $537 million in insured damages. Nearby farmers lost crops of barley, peas, and beans to hail the size of tennis balls. A wildlife centre was overrun with birds injured by the hail, including gulls, hawks, owls, and ducks. One *Calgary Herald* writer had a simple explanation: "The gods must be angry."

ABOVE A severe hailstorm hit Calgary on August 22, 2010, turning the city into a winter wonderland as icy hail collected on roads and in yards. The frequency of these types of damage-inducing storms gave rise to the area's nickname of "hailstorm alley." (Ted Rhodes/*Calgary Herald*)

FACING PAGE TOP LEFT A number of serious hailstorms smashed crops, gardens, homes, and vehicles in the Calgary area in summer 2012, causing hundreds of millions of dollars in damage. (Mike Drew/*Calgary Sun*)

FACING PAGE BOTTOM LEFT One of the most expensive hailstorms in North American history hit Calgary and area on July 12, 2010, causing more than $500 million in insurable damages, including these smashed greenhouses at the University of Calgary.

(Colleen De Neve/*Calgary Herald*)

FACING PAGE RIGHT An August hailstorm battered Edmonton in 2012, destroying gardens, smashing windshields, and plugging sewers, causing floods on dozens of streets. (Tom Braid/*Edmonton Sun*)

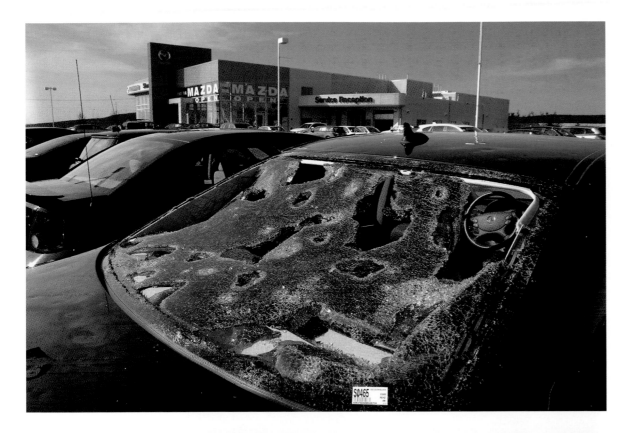
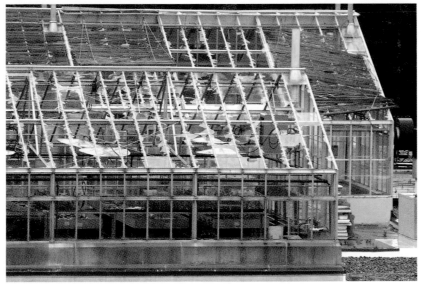
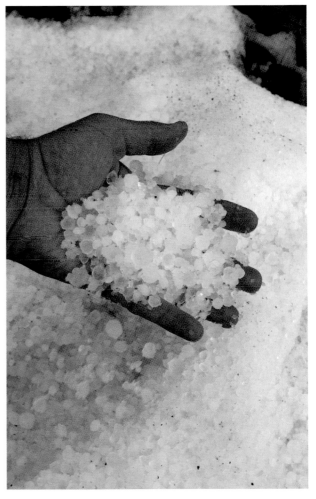

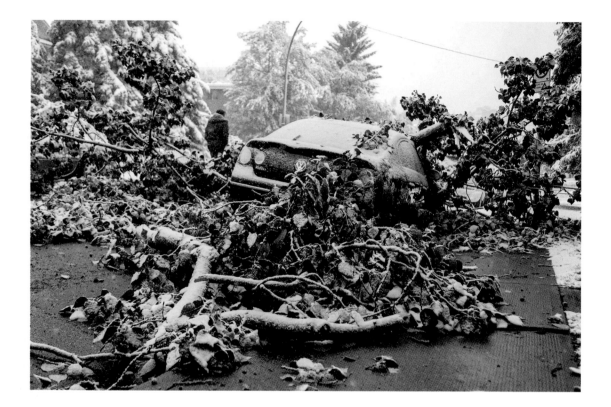

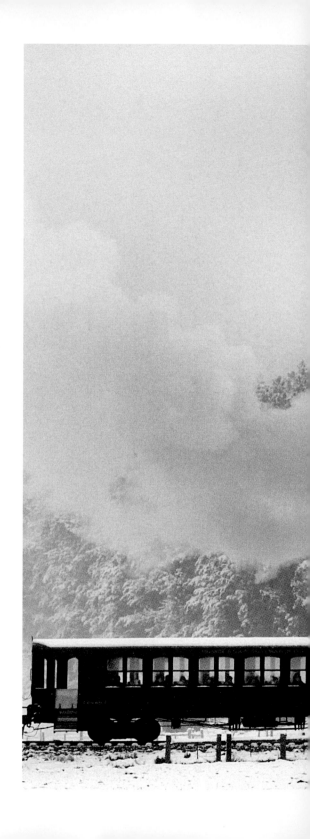

PREVIOUS SPREAD LEFT The start of spring doesn't necessarily mean the end of winter weather on the Prairies, as seen during this snowstorm in April 2012 in Edmonton. (Larry Wong/*Edmonton Journal*)

PREVIOUS SPREAD RIGHT An October blizzard left residents in Rapid City, South Dakota, digging out cars and sidewalks in 2013. (Associated Press)

ABOVE An early September storm (AKA "Snowtember") clobbered southern Alberta in 2014, dumping 30 centimetres of heavy wet snow, ruining crops, and damaging or destroying one million trees in Calgary. (Crystal Schick/*Calgary Herald*)

RIGHT The earliest area snowfall in 126 years dramatically changed the scenery for passengers on the vintage train between Hill City and Keystone, South Dakota, on September 11, 2014. (Associated Press)

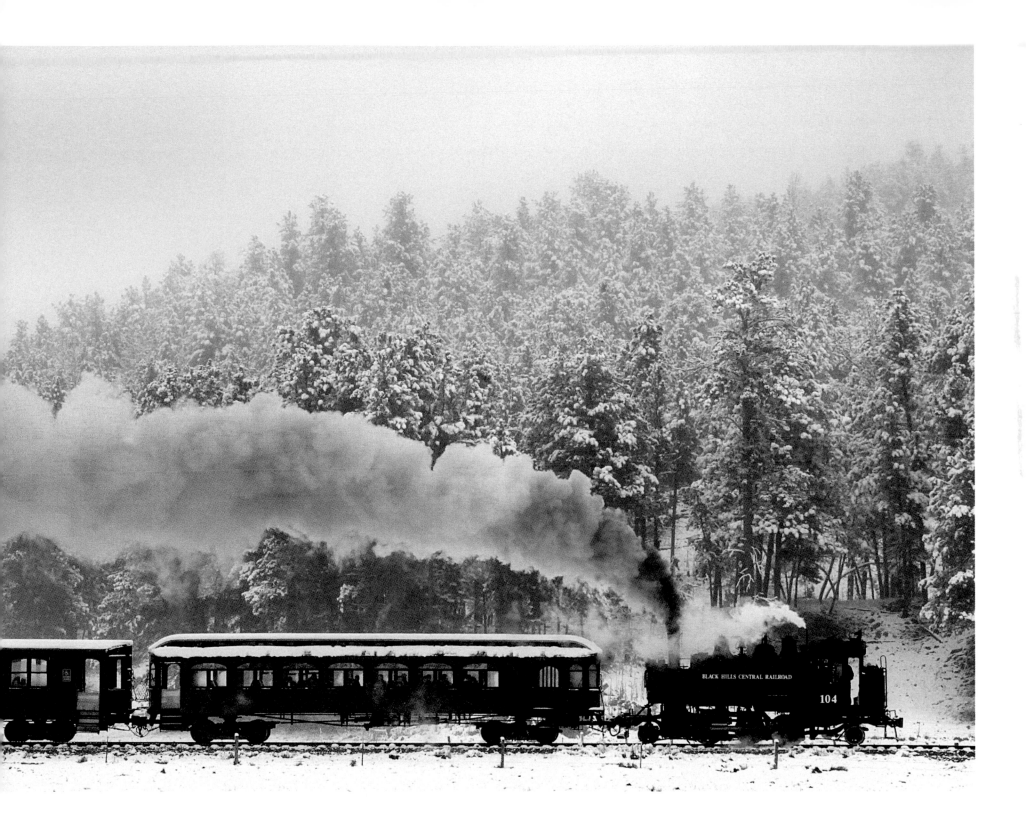

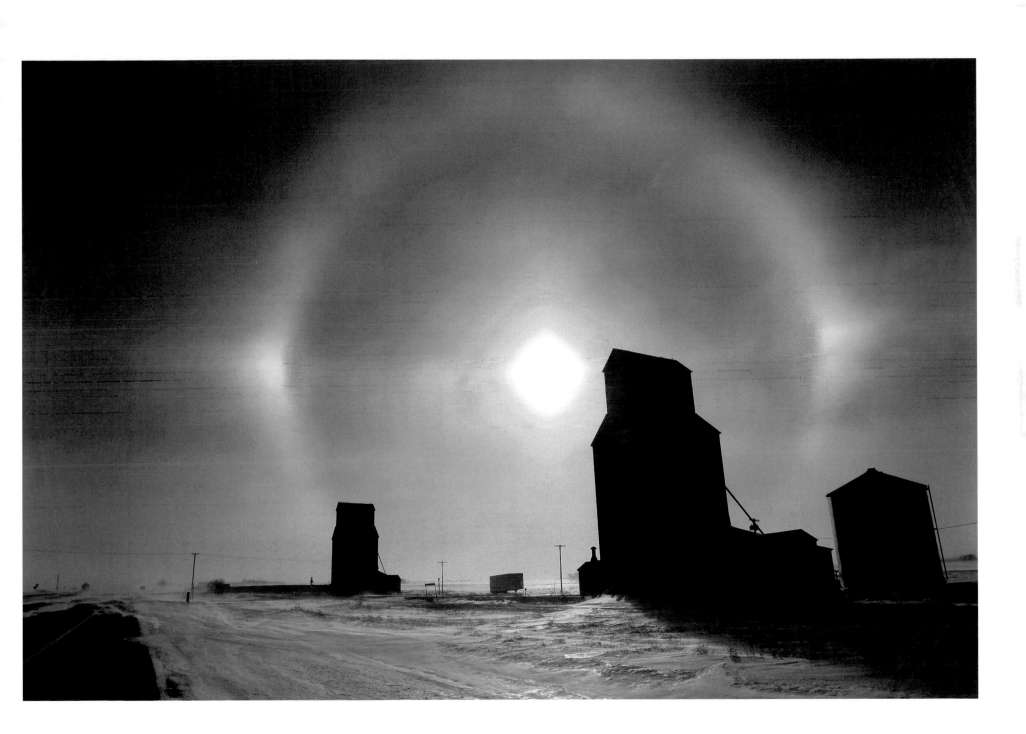

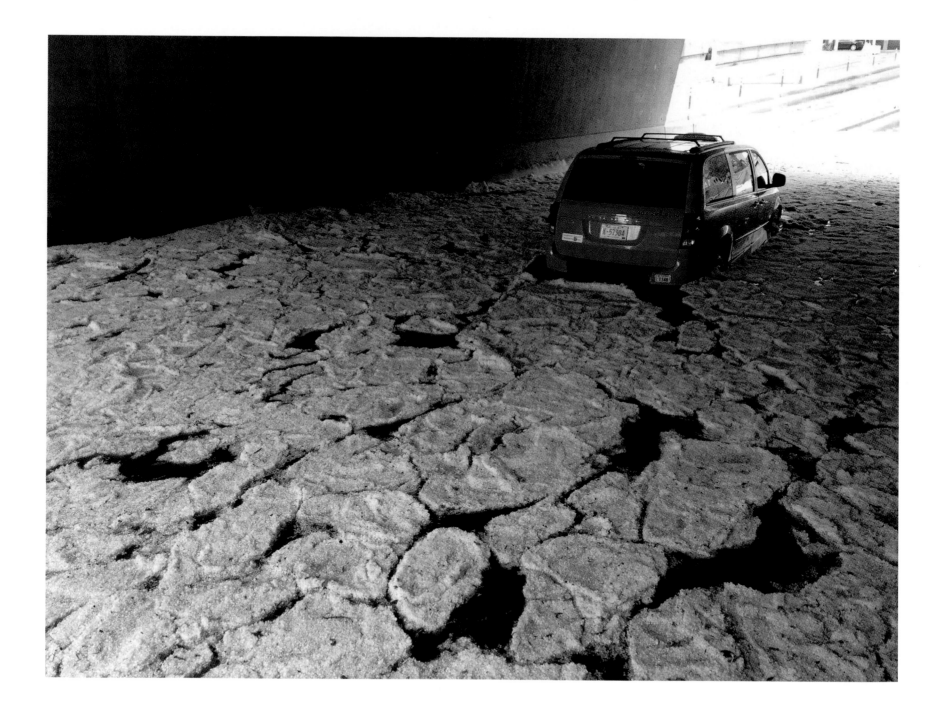

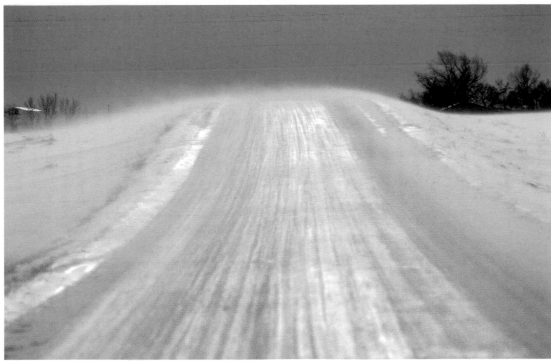

PREVIOUS SPREAD LEFT Strong winds sculpted snowdrifts near Strathmore, Alberta, 50 kilometres east of Calgary, in 2013. (Mike Drew/*Calgary Sun*)

PREVIOUS SPREAD RIGHT A sundog signalled a bitterly cold day in Bismarck, North Dakota, with the mercury plunging to −45°c including wind chill. (Associated Press)

FACING PAGE One of Calgary's infamous hailstorms led to clogged sewer systems and flooding on July 4, 2015. (Jim Wells/*Calgary Sun*)

TOP LEFT An August 2015 storm left this pedestrian navigating a huge pile of hail as he tried to cross the street. (Jim Wells/*Calgary Sun*)

BOTTOM LEFT Strong winter winds left many Saskatchewan rural roads as slippery as polished sheets of ice in January 2006.

(Joshua Sawka/*Regina Leader-Post*)

ABOVE Temperatures dipped below -20°C in Saskatoon on January 31, 2010, but it didn't keep Darrell McIntyre from going for a walk by the river. (Greg Pender/*Saskatoon StarPhoenix*)

RIGHT In December 2010 Heather Dawson and her greyhounds were dressed for a winter day in Winnipeg, which Environment Canada rates as Canada's coldest major city. (Brian Donogh/*Winnipeg Sun*)

FACING PAGE It wouldn't be winter on the Prairies if the temperature didn't drop to –30°c. On average, the mercury falls to –30°c in Winnipeg (pictured here in 2015) twelve times each winter. Annually in Regina, that occurs an average of eleven times; in Saskatoon, it's seven times; and in Edmonton and Calgary, it occurs three times.

(Chris Procaylo/*Winnipeg Sun*)

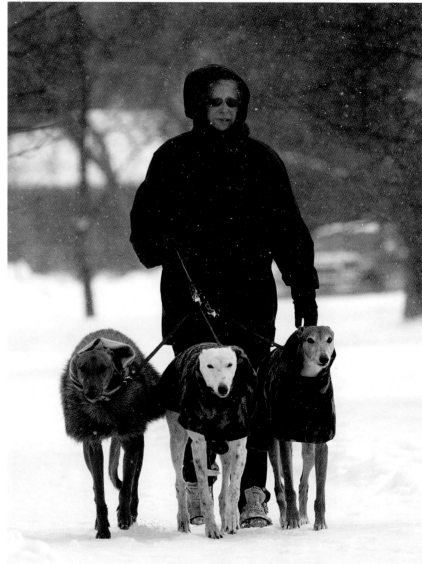

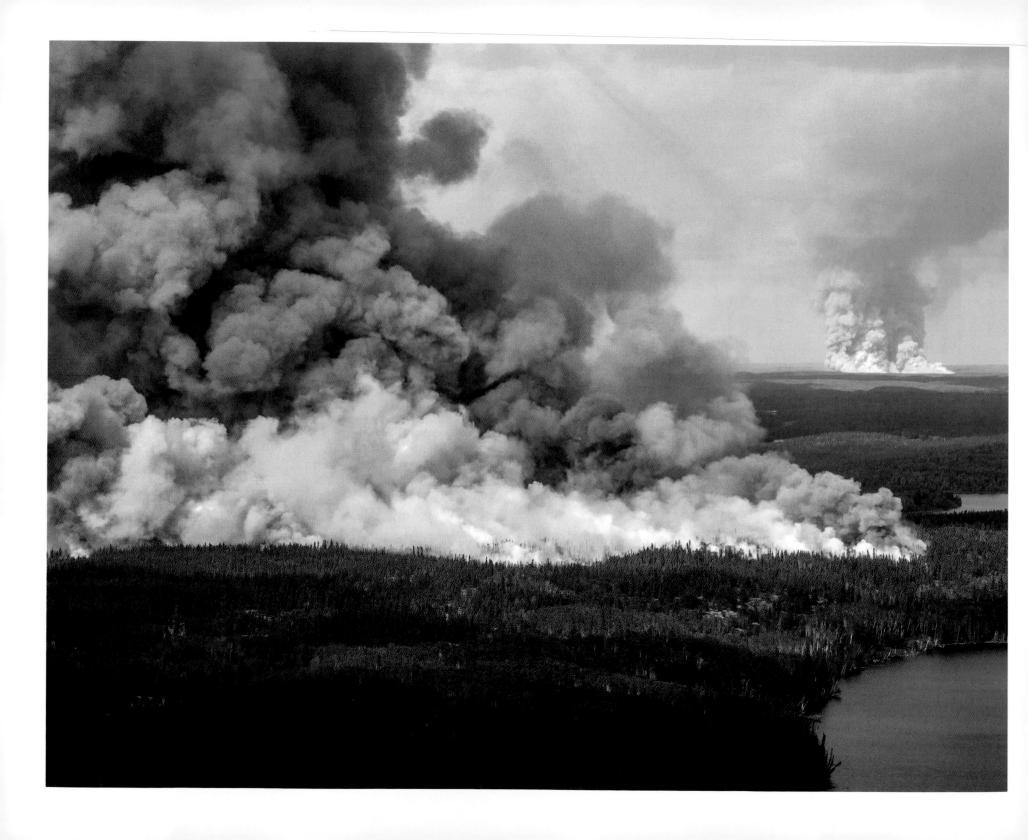

FOUR

FIRE

THE ANCIENT GREEKS used a system of classical elements—fire, water, air, and earth—to explain the complexities of matter and the nature of the world. Humankind's relationship with the element fire, however, may be the most complicated. Without fire, there's no cooking, no heat, and little chance of survival. But when fire rages out of control, it's an element both harmful and hellish.

On the Prairies, weather factors into, and even causes, significant wildfires each year. Sparse precipitation, downright droughts, high winds, and lightning have contributed to wildfires on the Prairies for centuries. The risk of deadly fires, however, increased over the years as population in the region grew.

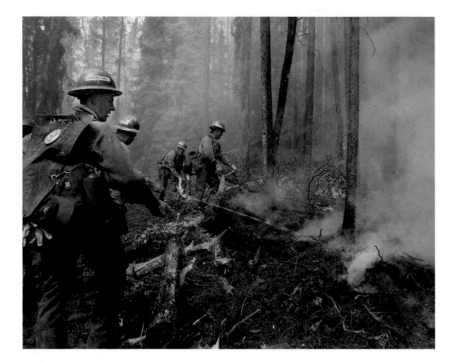

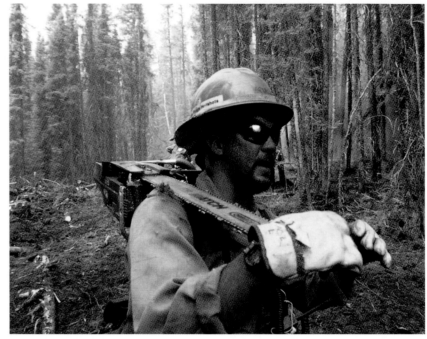

As settlers arrived in the 1800s, they witnessed blazes devour crops, pastures, and livestock that stood in their path. Fire consumed barns, homes, and even entire towns. Tragically, these fires also took human lives. With little equipment or expertise in fighting blazes available, both grass fires and forest fires could easily spread and burn out of control. Settlers were often at the mercy of the weather—praying for rain and divine intervention—when it came to stopping conflagrations.

A turning point in the fight against wildfires occurred in 1910 after lightning strikes started a series of fires in parched parts of Alberta, Montana, and Idaho. One of the largest was a late-August blaze known as the Big Blowup Fire, in which flames darted

TOP LEFT A warm and dry winter was a contributing factor to the 1998 Virginia Hills fire, near Whitecourt, Alberta, about 175 kilometres northwest of Edmonton. (*Edmonton Journal* archives)

TOP RIGHT The Virginia Hills fire scorched more than 170,000 hectares of timber. (*Edmonton Journal* archives)

FACING PAGE An out-of-control grass fire spread to nearby trees in May 2009, near Bruderheim, Alberta, about 45 kilometres northeast of Edmonton.

(Brian J. Gavriloff/*Edmonton Journal*)

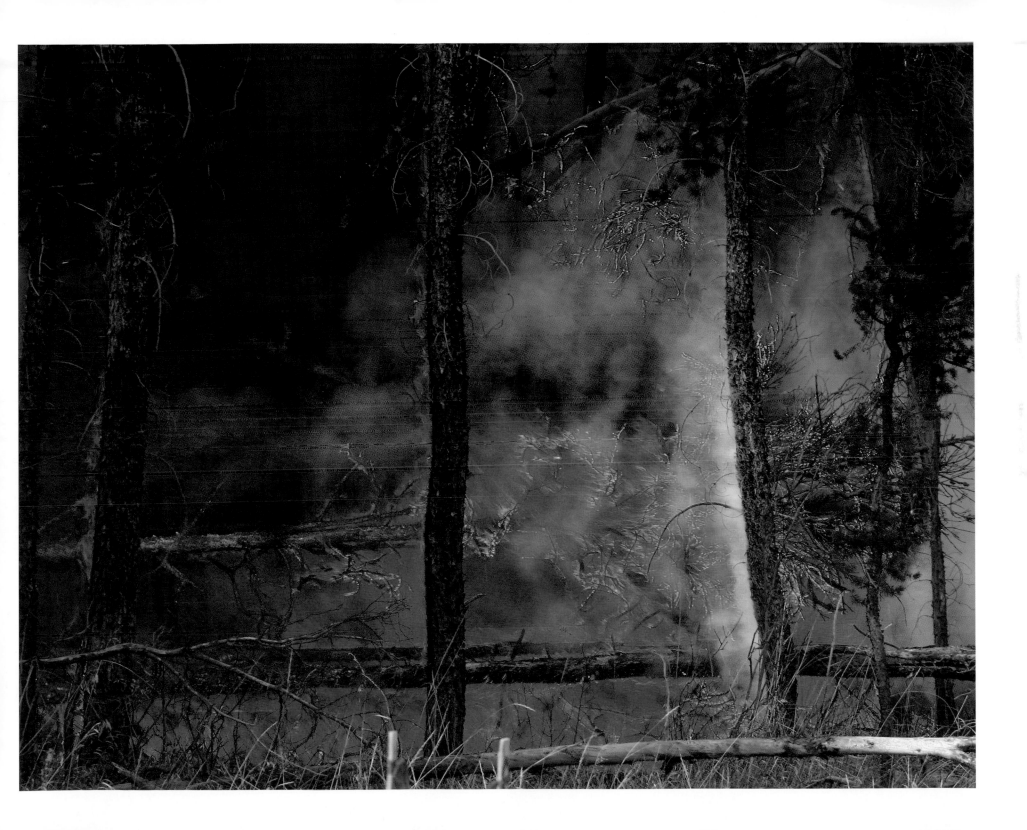

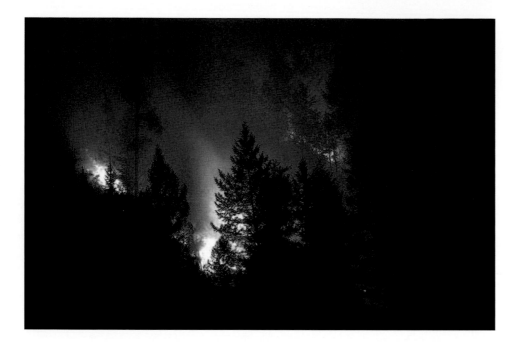

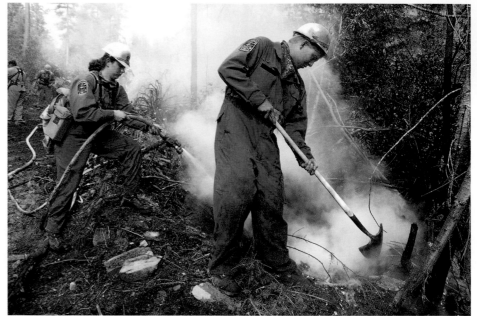

northwards from the United States and burned into Alberta. More than 1.2 million hectares were scorched in the U.S.; entire towns were destroyed; and eighty-seven people, mostly firefighters, were killed by the fire. The destruction prompted the American government to spend federal money to fight forest fires for the first time and, in the public imagination, revealed firefighters as heroes.

Although it helped that governments began battling blazes, fire tragedies still occurred. A series of fires in Saskatchewan and Alberta in 1919 killed at least thirteen people, injured dozens more, and burned 2.8 million hectares, making it Canada's largest grouping of forest fires. The town of Lac La Biche, Alberta, 220 kilometres northeast of Edmonton, was in the eye of the firestorm; residents fled into a lake, swimming out to safety and watching as almost the entire town burned down. At Lac des Îles in Saskatchewan, an

extended family of Indigenous people became surrounded by the flames; eleven family members died. Many of the fires were caused by lightning strikes in drought-stricken areas and fanned by high winds.

Similar conditions contributed to a 1950 forest fire in Alberta and British Columbia—the Chinchaga River fire. It was notorious not only for being the single largest forest fire in North America; it also became infamous for causing a strange phenomenon known as the Great Smoke Pall. The blaze's smoke was detected as far away as Great Britain and the Netherlands, but in North America the effects were felt most severely. Smoke darkened the skies as far away as New York and Cleveland, where baseball stadiums were forced to turn on their lights for afternoon games. In Florida, streetlights came on during the day. People living along the East Coast worried

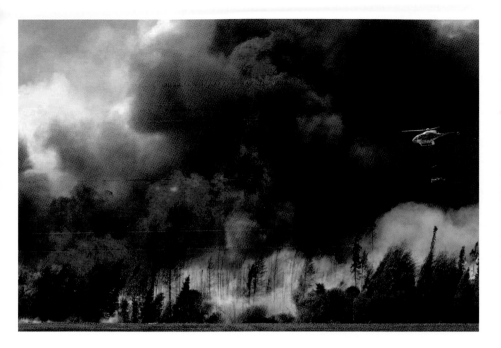

that the midday darkness was caused by the apocalypse, an atomic explosion, a surprise eclipse, or even an alien invasion. Across the continent, animals acted strangely, not knowing if it was day or night. And in the skies over many states and provinces, the sun took on a blue or violet hue because of the Great Smoke Pall.

Over the years, other vast wildfires took their toll. In 1989, Manitoba experienced one of its worst fire seasons, with more than 1,100 wildfires ignited in the northern and central parts of the province, leading to thirty-two communities evacuating more than 24,000 people and racking up $65 million in costs. In 2015, a dry winter, spring, and summer contributed to more than 100 wildfires raging across Saskatchewan in June and July, leading to the evacuation of 13,000 people—the largest such evacuation in the province's history.

FACING PAGE LEFT The American wildfires of 2000 became noteworthy for their duration, frequency, and size; they caused more than US$2 billion damage in Montana (pictured) and neighbouring states. (Postmedia archives)

FACING PAGE RIGHT The fires in 2000 attracted international media attention and assistance, including this Ontario firefighting crew working near the Flathead Indian Reserve in Montana. Hot, dry summer weather was a key reason why the fires spread.

(Colleen De Neve/*Calgary Herald*)

ABOVE LEFT To prevent forest fires, officials often undertake controlled burns, such as this planned blaze in 2001 near Flatbush, Alberta, about 140 kilometres north of Edmonton.

(Rick MacWilliam/*Edmonton Journal*)

ABOVE RIGHT While a massive fire would hit Slave Lake, Alberta, in 2011, another serious, but smaller, blaze burned a few kilometres from town ten years earlier. Here, conservation officer Kyle Lester directed traffic away from dangerous back roads.

(Rick MacWilliam/*Edmonton Journal*)

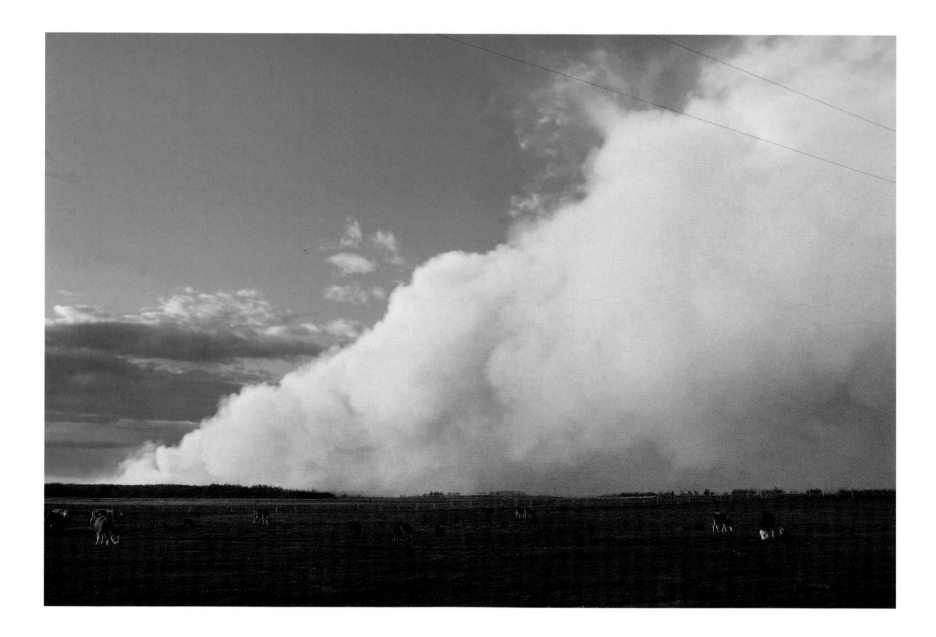

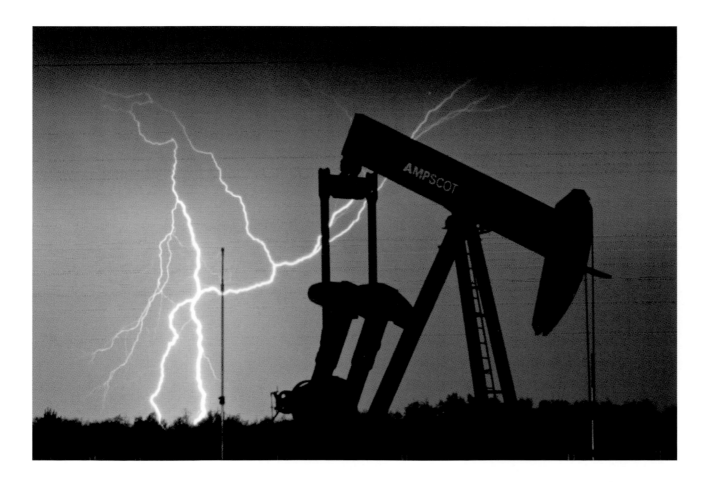

FACING PAGE Grass fires pose threats to both farmland and livestock, demonstrated by these 2002 out-of-control flames near Gibbons, Alberta, about 35 kilometres northeast of Edmonton. (John Lucas/*Edmonton Journal*)

LEFT Lightning strikes are responsible for starting 45 percent of the forest fires that occur in Canada each year. Here, lightning lit up the sky west of Edmonton in 2005.

(Darryl Dick/*Edmonton Sun*)

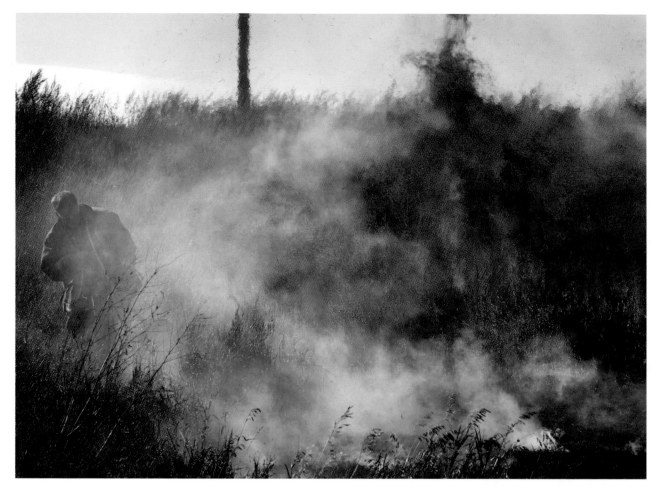

The two most financially damaging blazes struck the Prairies in 2011 and 2016. The first, in 2011, hit the seven-thousand-person Alberta town of Slave Lake. Nestled within a dense boreal forest, flames had previously licked the edge of the community. But always in the past, the fire was stopped before invading the town. That changed in 2011 when a blaze swept through the community, destroying more than five hundred homes, 4,700 hectares of land, and hundreds of cars, trucks, and campers. At the time, the Slave Lake fire—with $750 million in costs and one-third of the town destroyed—became the second-biggest insurable disaster in Canadian history.

A terrifying inferno in Fort McMurray five years later became the costliest disaster for insurers in Canadian history, chasing 88,000 people from their homes and devouring thousands of structures.

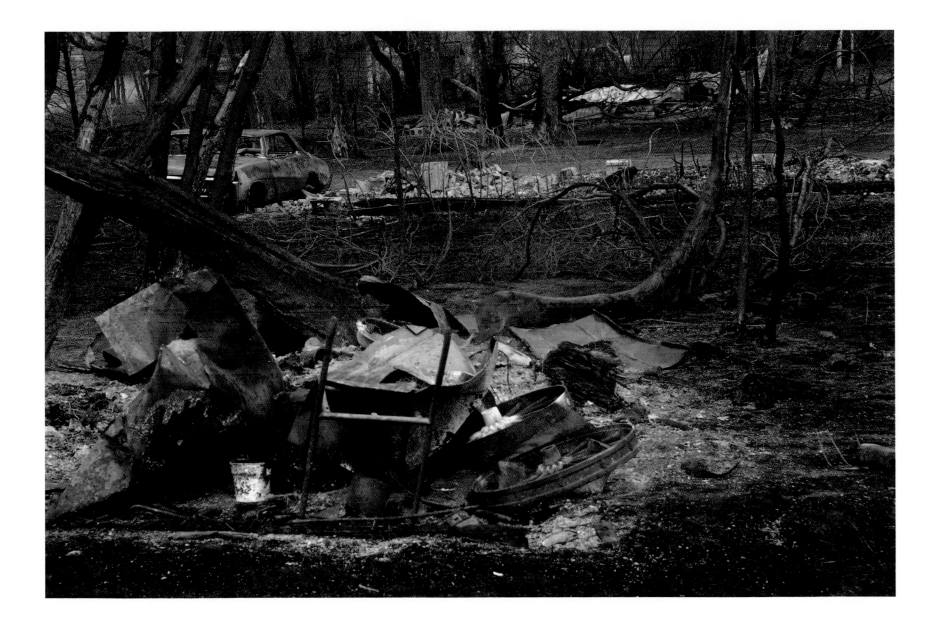

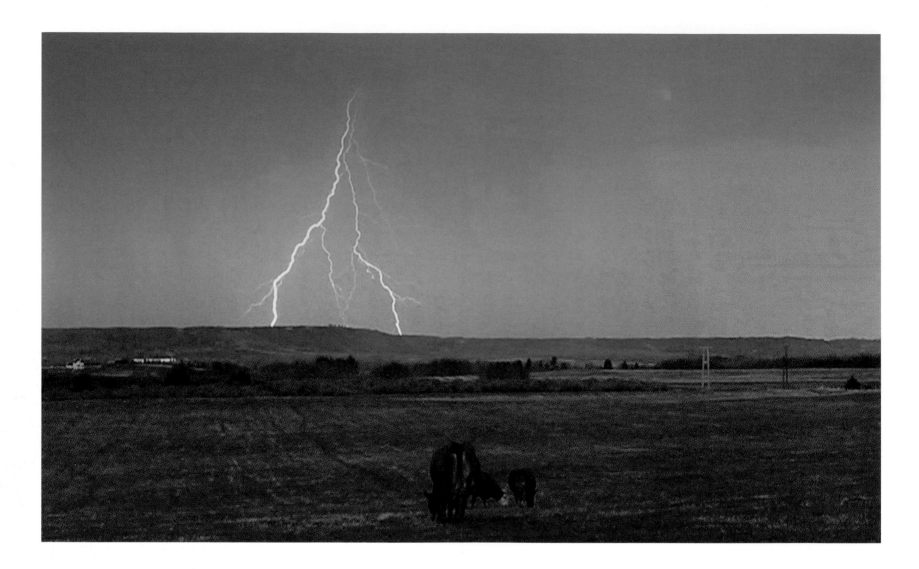

ABOVE Farmers watch lightning strikes closely, knowing they can lead to fires if they strike dry grassland. These bolts hit west of Calgary in May 2010.

(Mike Drew/*Calgary Sun*)

FACING PAGE The conservation area of Cranberry Flats, just outside Saskatoon, caught fire in 2010. Fortunately, the weather co-operated and winds became calm, allowing firefighters to bring the flames under control within an hour.

(Richard Marjan/*Saskatoon StarPhoenix*)

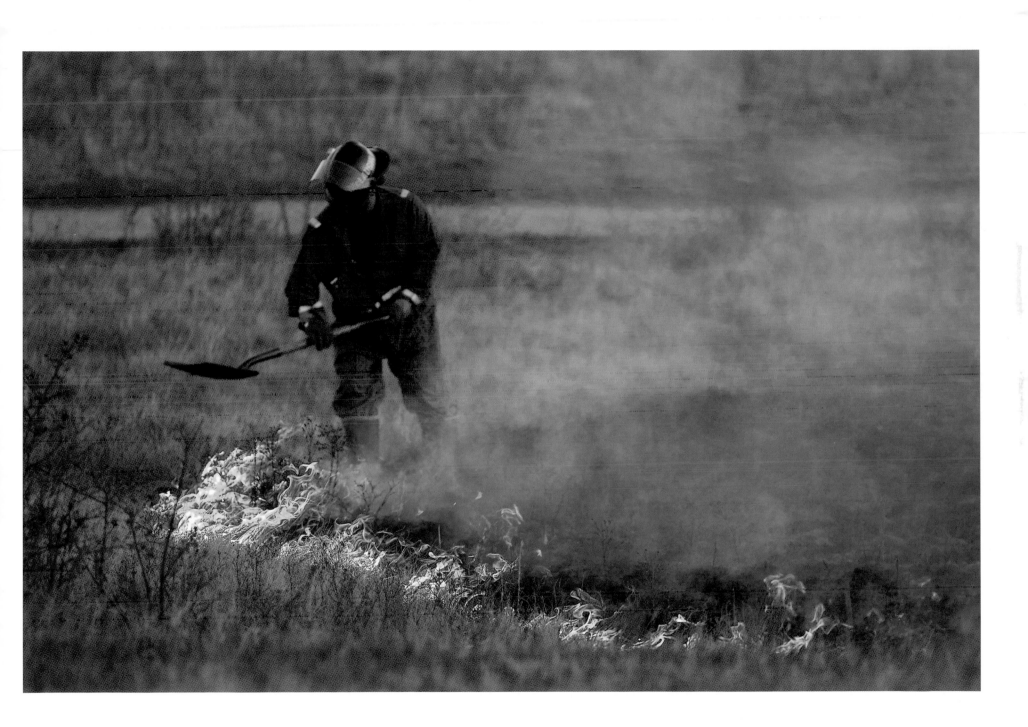

TOP RIGHT More than five hundred homes and businesses were lost in the 2011 Slave Lake fire, about 200 kilometres northwest of Edmonton.
(Shane O'Brien/*Edmonton Journal*)

BOTTOM RIGHT About one third of the 7,000-person town of Slave Lake was destroyed by the blaze. With damages totalling $750 million, the fire became the second-biggest insurable disaster in Canadian history at the time.
(Rick MacWilliam/*Edmonton Journal*)

FACING PAGE Prince William, Duke of Cambridge, and Catherine, Duchess of Cambridge, visited Slave Lake in July 2011. They adjusted their royal tour of Canada that year to pay a visit to the fire-ravaged town.
(*Edmonton Journal* archives)

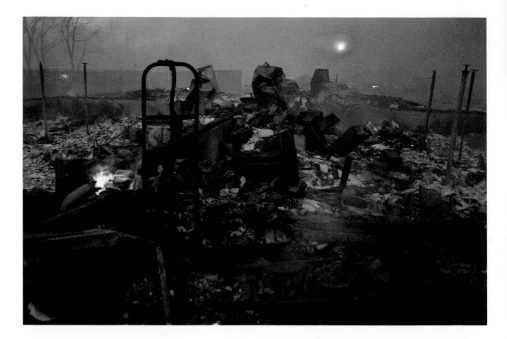

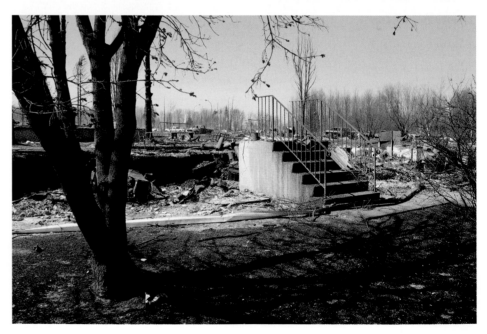

The fire—causing $9.9 billion in direct and indirect costs, including $3.7 billion in insured damages—simply became known as "The Beast." It started on May 1: a modest blaze, then called the Horse Creek Fire, that was the size of a few football fields. Within two days, it had become a giant inferno tearing through Fort McMurray.

The images of thousands of people fleeing a fire of biblical proportions are frighteningly unforgettable. Hundreds of residents posted video and photos of their treacherous journey on social media. Embers, along with burning branches and leaves, rained down upon people as they left their homes. Enormous flames lined the highways as escape routes narrowed. Sadly, two evacuees lost their lives in a car accident after leaving the city; one of them was a firefighter's daughter.

Ultimately, the fire destroyed 2,400 buildings, including 1,800 homes, dozens of multi-family structures that housed 600 apartments, 2 hotels, and a 665-bed work camp.

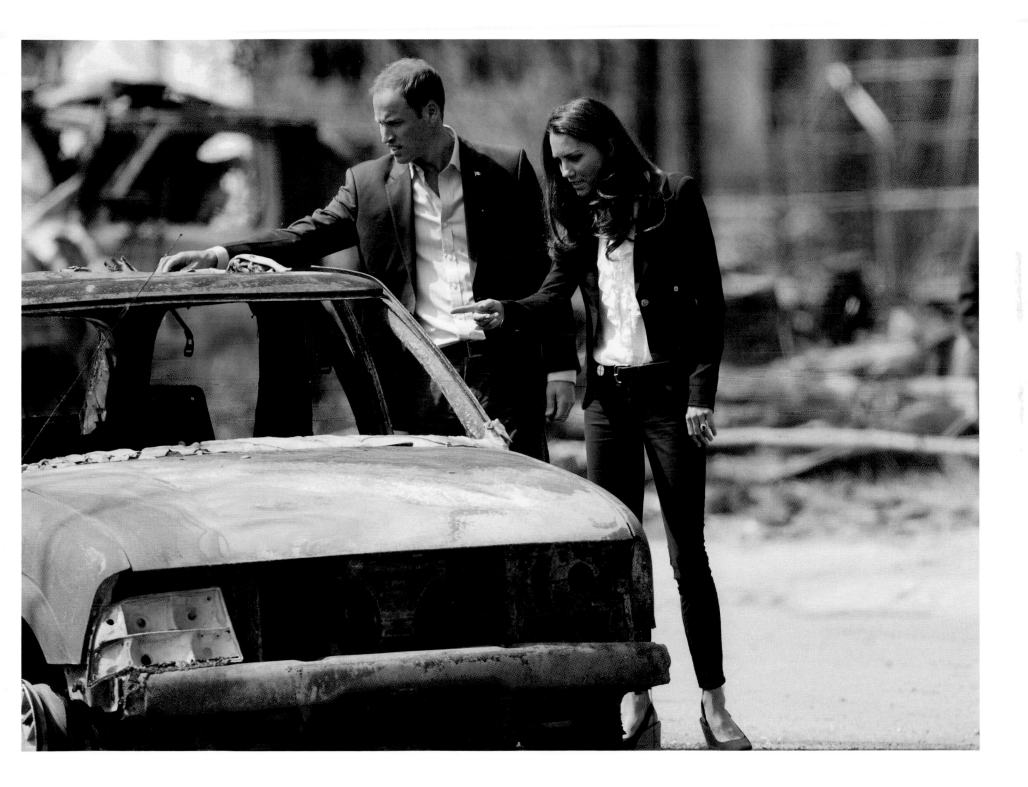

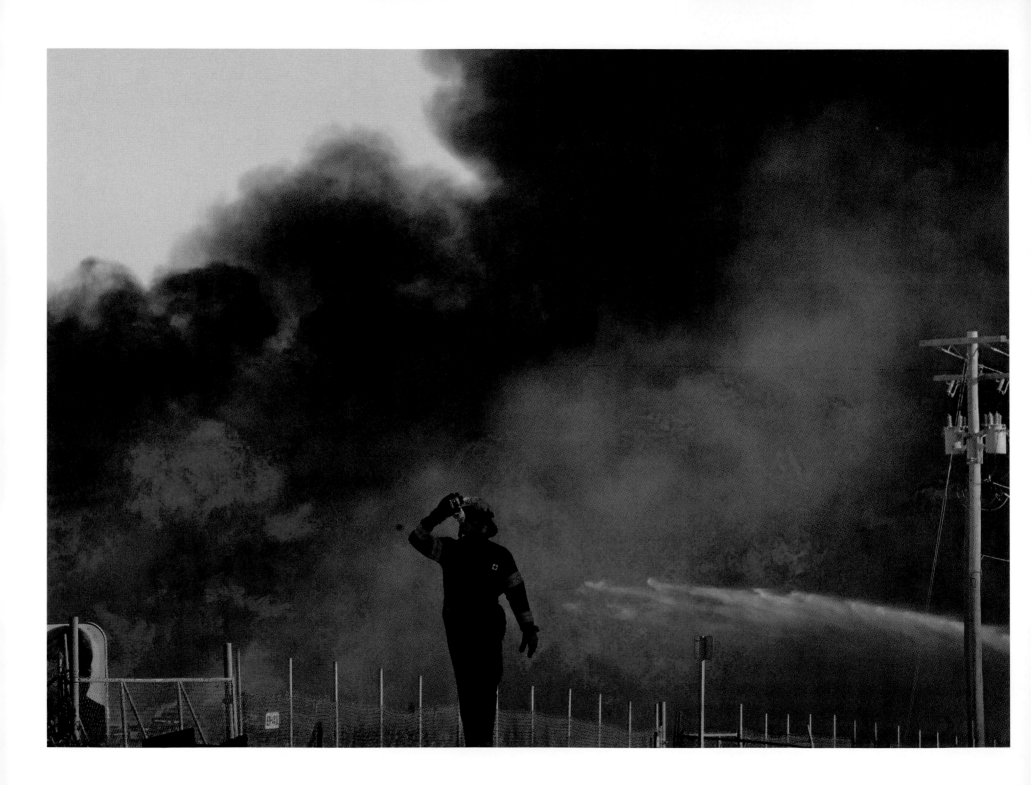

The losses broke hearts, but not spirits. The heroic work of firefighters, who fought to save whatever they could, proved inspirational. While 2,400 buildings were lost, 25,000 were saved. Firefighters from across the province and country joined in the battle; some even came from as far away as South Africa.

Canadians from coast to coast to coast donated to fire-relief funds. The Red Cross raised $299 million for victims. A six-hour, seventeen-act Fire Aid concert in Edmonton garnered $2 million to help. And new initiatives continued to pop up, including one started by victims of the 2013 Alberta flood. They collected Christmas ornaments for Fort McMurray victims as a reminder that they're not alone and that some day, normalcy will return.

The number of people who wanted to support survivors of the fire was amazing, said Melissa Blake, the mayor of the Fort McMurray region, Wood Buffalo. Repairing all the damage may take a long time, she noted, but "the hope and compassion and support are what's going to carry us through to a better day."

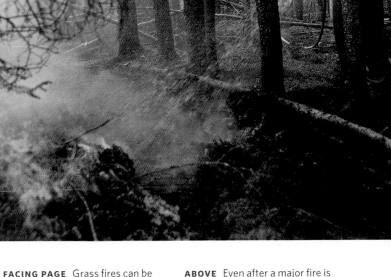

FACING PAGE Grass fires can be a Prairie hazard in both rural and urban areas. Here, a fire started in Regina in 2012 after a passing train sparked a patch of grass. The fire spread to a nearby business that sold wooden pallets and a large blaze resulted.

(Don Healy/*Regina Leader-Post*)

ABOVE Even after a major fire is snuffed out, flames can pop up in the following days, as seen in this 2015 Saskatchewan blaze.

(Liam Richards/*Saskatoon StarPhoenix*)

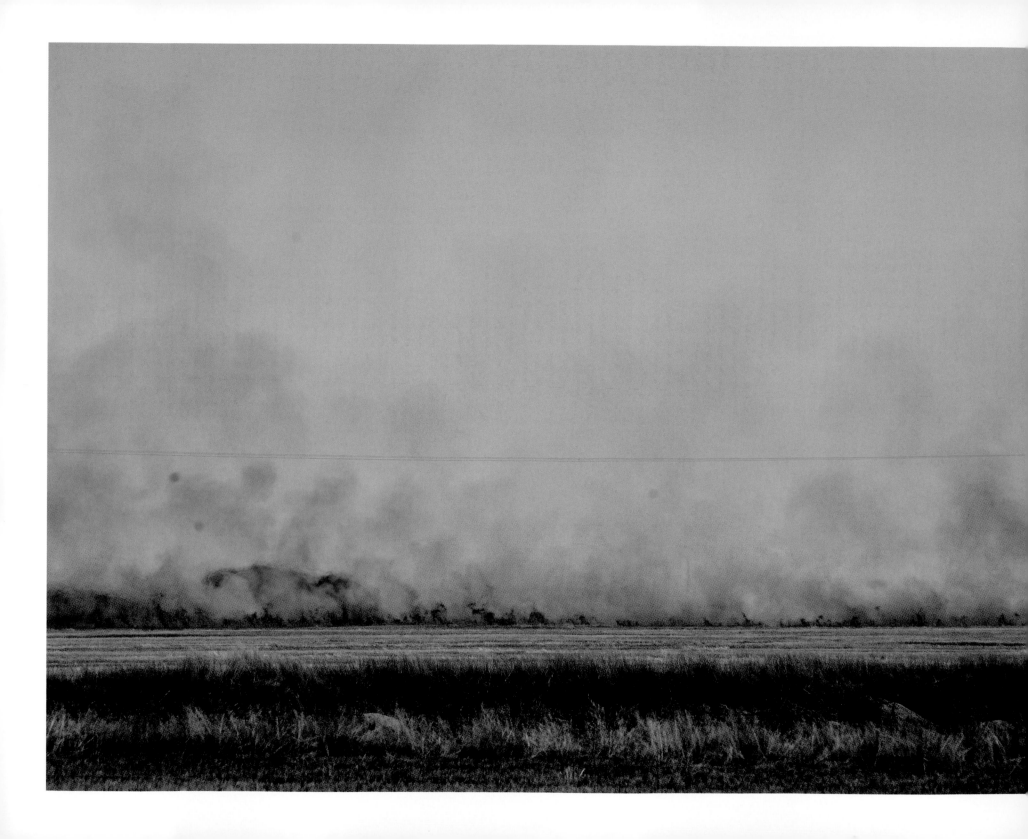

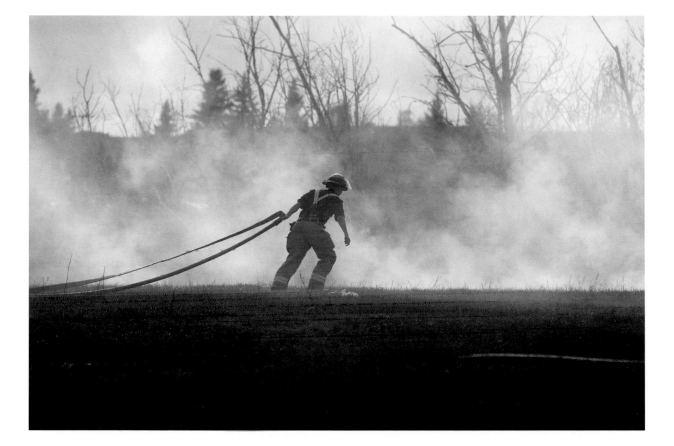

LEFT A massive Saskatchewan fire consumed grass and grain fields in 2014, with areas near Kronau and Francis, 25 and 65 kilometres southeast of Regina, experiencing the most intense flames. Local residents used tractors and graders to create firebreaks in the fields to prevent flames from jumping to farmhouses.

(Rachel Psutka/*Regina Leader-Post*)

ABOVE High winds contributed to a fire advisory in Grande Prairie, Alberta, 450 kilometres northwest of Edmonton, shortly before this grass fire broke out in April 2015.

(Alexa Huffman/Postmedia archives)

OVERLEAF LEFT Hot weather, dry conditions, and lightning strikes were blamed for a massive number of the fires that plagued northern Saskatchewan in 2015, such as this forest fire near Weyakwin, about 280 kilometres north of Saskatoon. (Liam Richards/*Saskatoon StarPhoenix*)

OVERLEAF RIGHT A July 2014 forest fire left this stand of trees almost completely wiped out. (Christina Ryan/*Calgary Herald*)

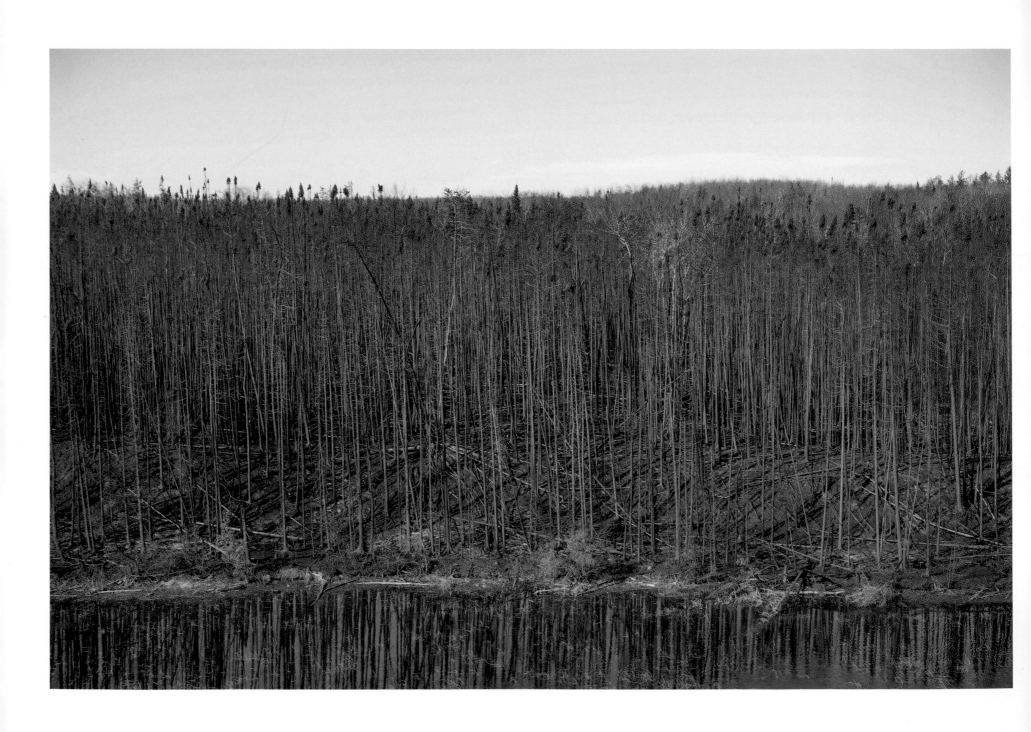

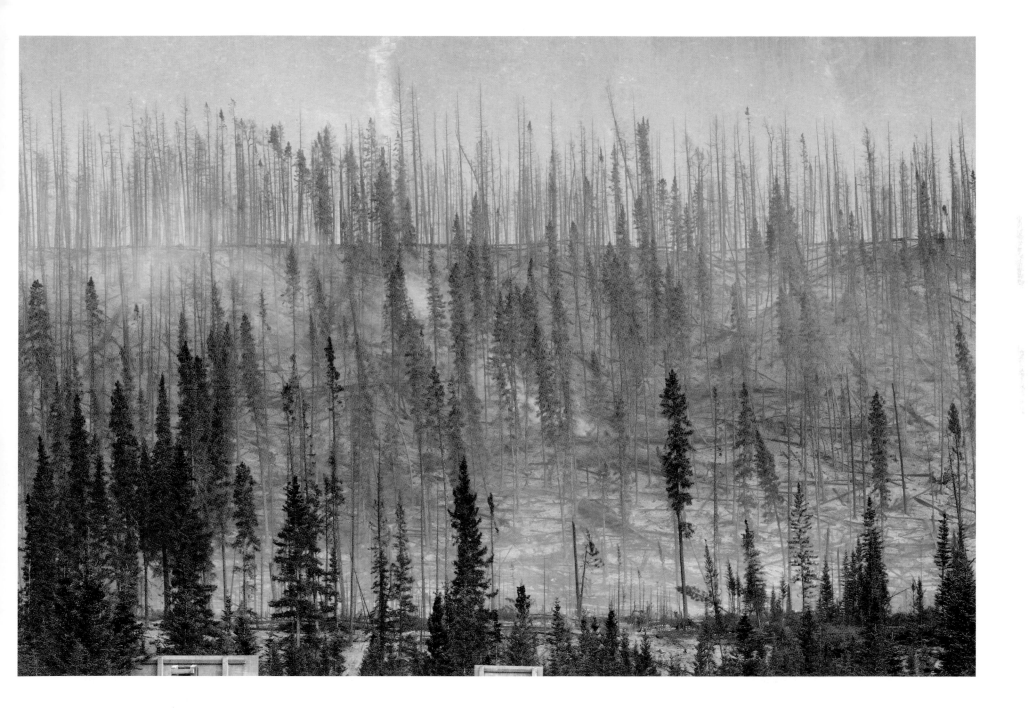

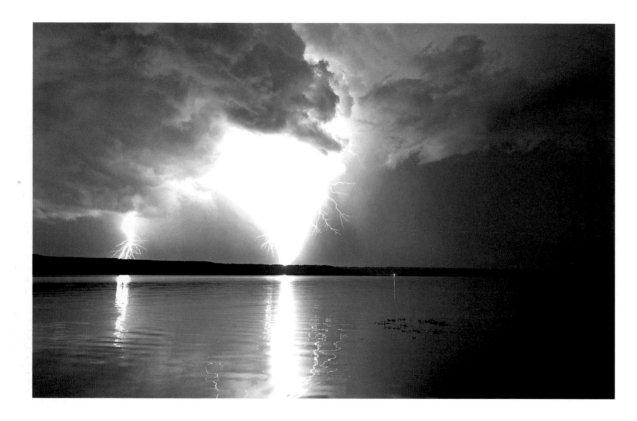

ABOVE A thunder, lightning, and hailstorm wreaked havoc on farmers' fields in Saskatchewan in August 2014. Lightning, which started one small fire, provided a spectacular light show as seen in this photo of Pasqua Lake, northeast of Regina. (Bryan Schlosser/*Regina Leader-Post*)

RIGHT Warm and humid air masses hung over much of Saskatchewan in July 2015. The result was a series of thunderstorms, with lightning that started a few minor fires and damaged power poles.
(Bryan Schlosser/*Regina Leader-Post*)

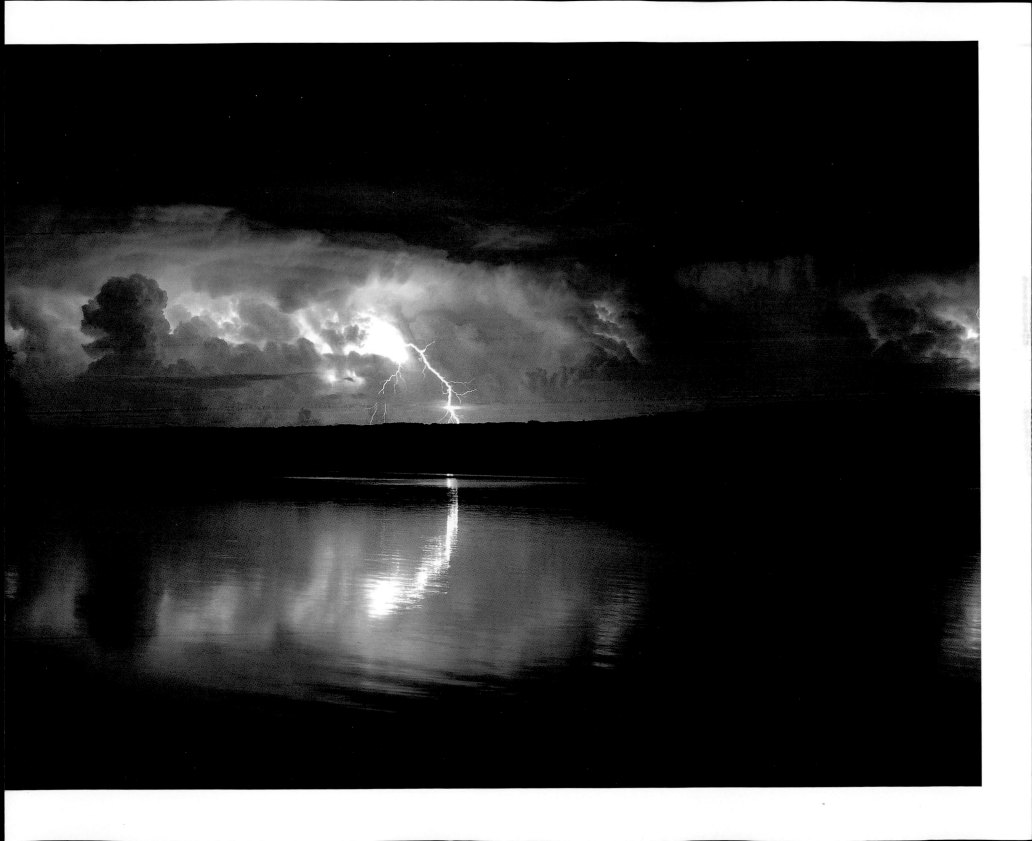

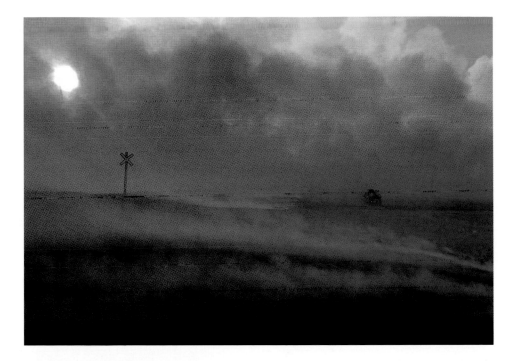

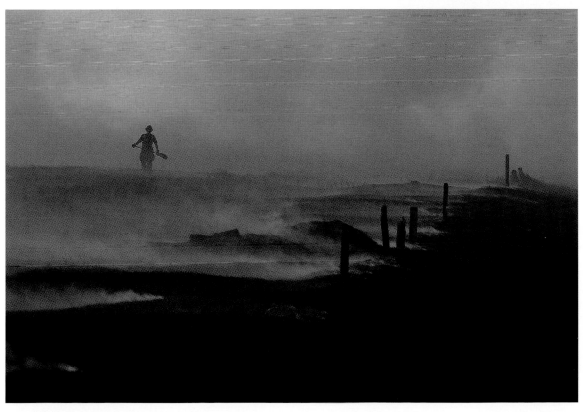

FACING PAGE Firefighters were able to quickly get control of this wildfire at the Condie Nature Refuge outside of Regina in April 2016.

(Bryan Schlosser/*Regina Leader-Post*)

LEFT A spark from an open pit fire was believed to be the cause of the blaze; dry weather conditions allowed flames to spread.

(Bryan Schlosser/*Regina Leader-Post*)

ABOVE More than 240 hectares of land, along with a few sheds, were destroyed by the blaze.

(Bryan Schlosser/*Regina Leader-Post*)

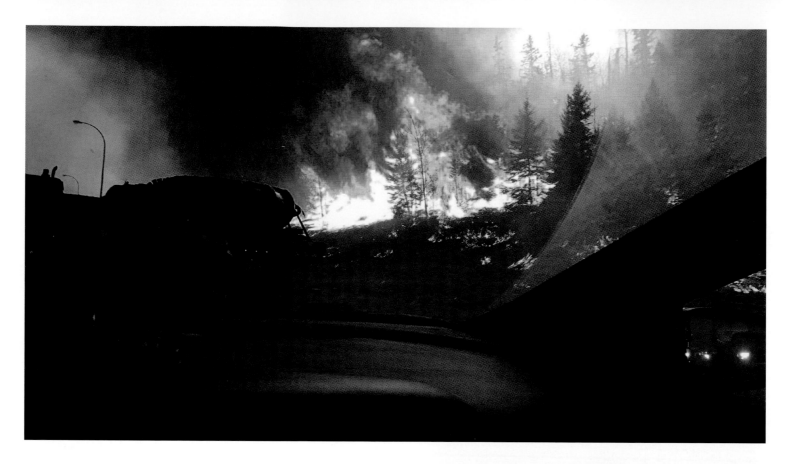

ABOVE After a wildfire began tearing through Fort McMurray, 88,000-plus residents evacuated on May 3, 2016; many were forced to drive through a dangerous inferno, with burning branches and flaming embers falling upon their vehicles.

(Robert Murray/Postmedia archives)

RIGHT People across the province welcomed evacuees into their communities. Here, volunteers in the hamlet of Grassland directed evacuees to a food and gas stop.

(Larry Wong/*Edmonton Journal & Sun*)

FACING PAGE Vehicles headed south on Highway 63 to escape the inferno.

(Robert Murray/Postmedia archives)

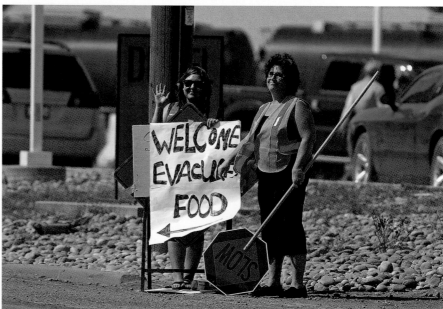

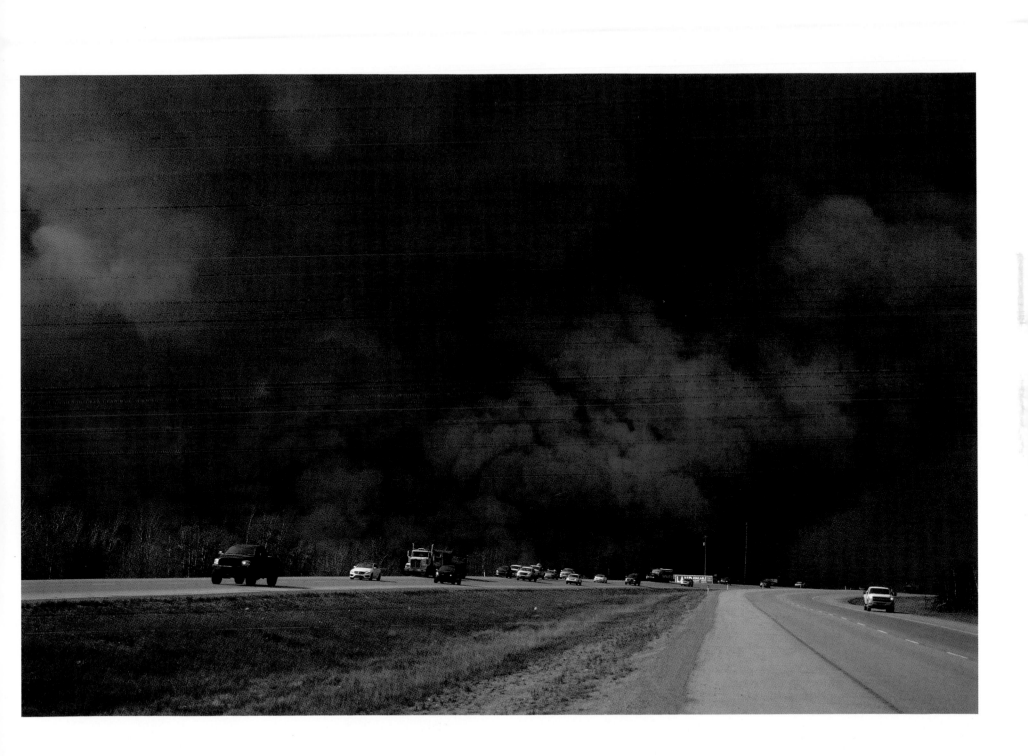

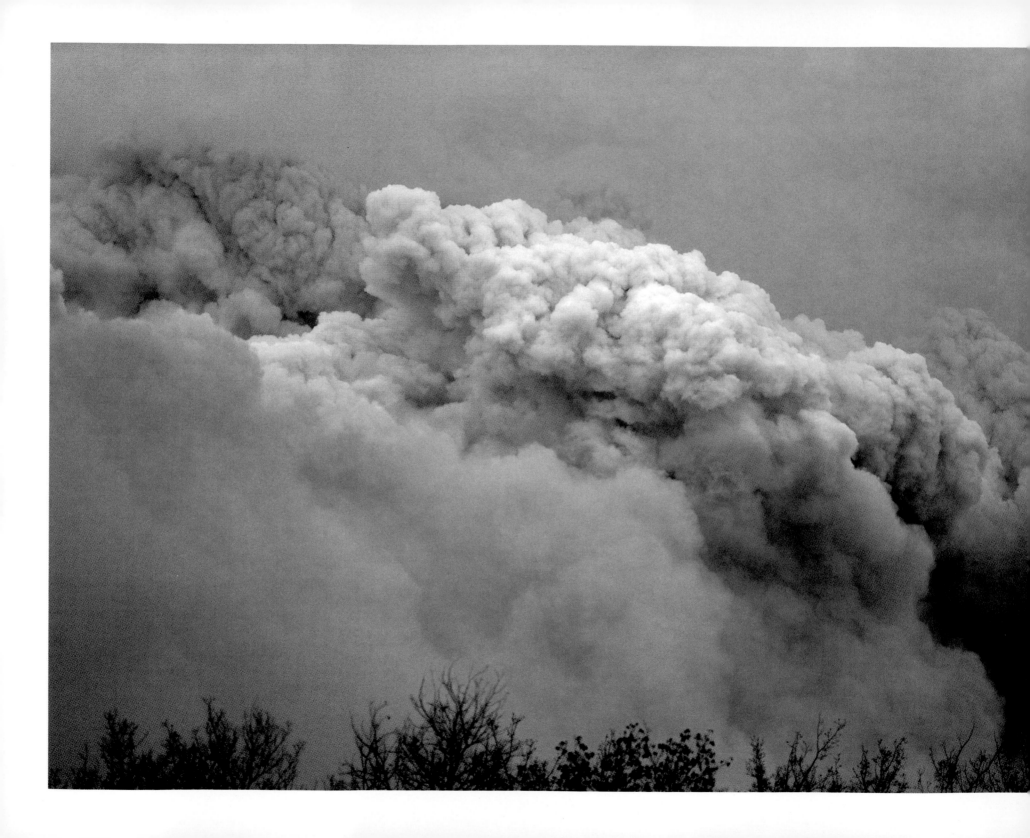

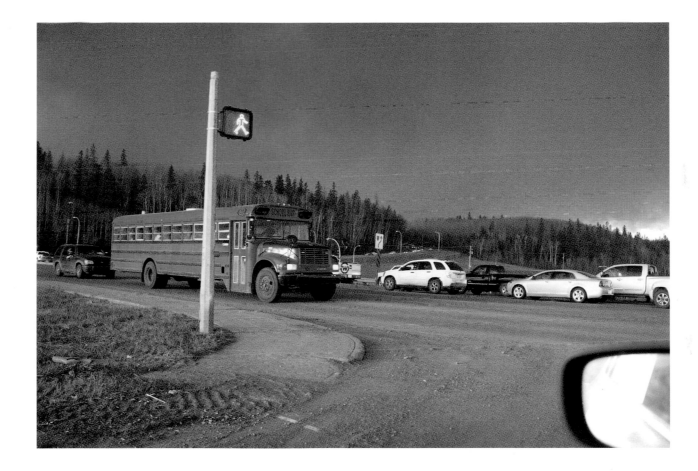

LEFT Smoke blew across the West, as the 2016 fire moved from Fort McMurray into Saskatchewan. The blaze wasn't classified as being under control until July 5—more than two months after it started.

(Larry Wong/*Edmonton Journal & Sun*)

ABOVE The abrupt evacuation of Fort McMurray led to some people fleeing to the north and others to the south, splitting up families for several days. School buses of children took the closest exit out of town, while some of their parents were forced to flee in the opposite direction.

(Robert Murray/Postmedia Network)

TOP RIGHT This neighbourhood, Beacon Hill, was one of the hardest-hit areas of Fort McMurray.

(Ian Kucerak/*Edmonton Journal & Sun*)

BOTTOM RIGHT Resident Terry Brittain found this beloved family item while searching the ruins of his home on June 8, 2016.

(Ian Kucerak/*Edmonton Journal & Sun*)

RIGHT The flames wiped out entire swaths of communities.

(Larry Wong/*Edmonton Journal & Sun*)

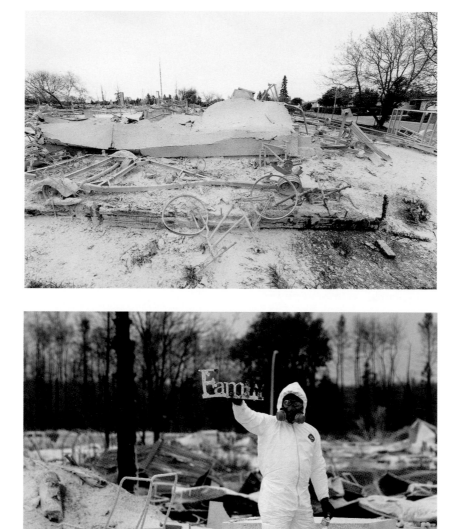

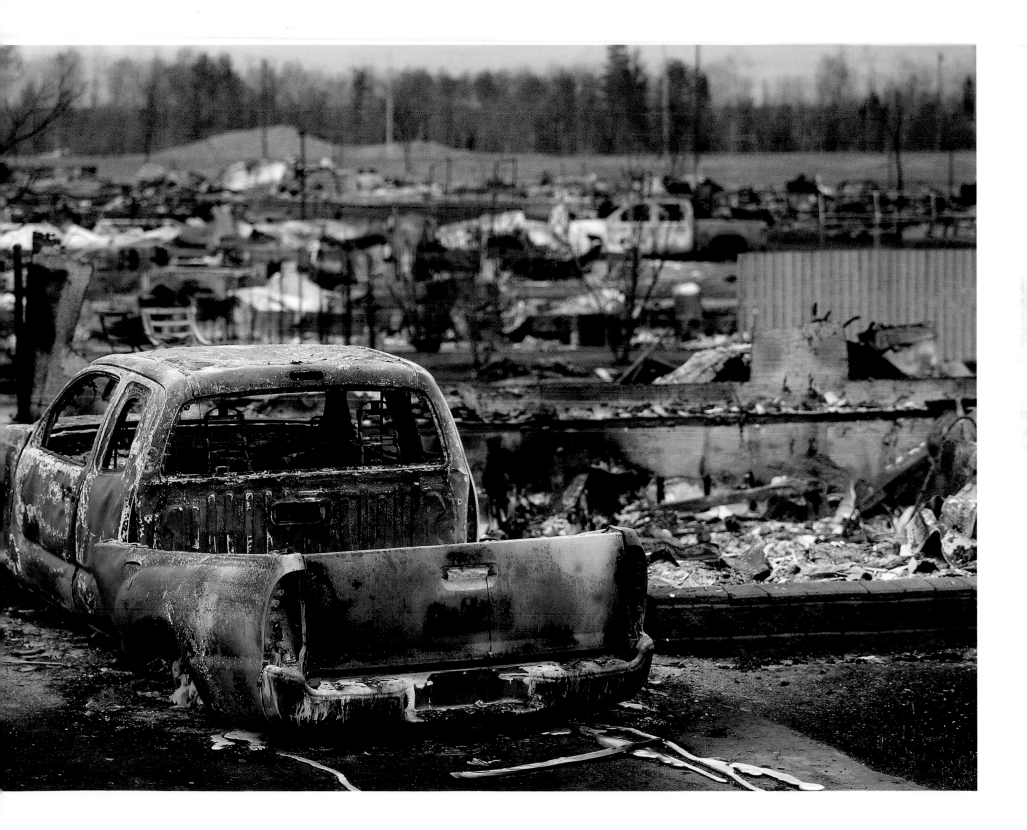

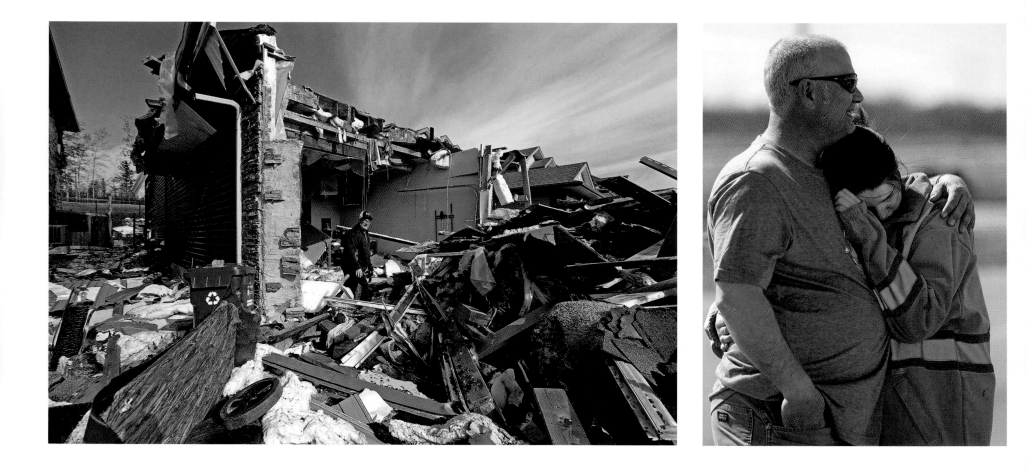

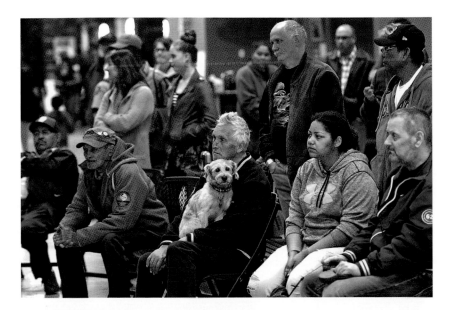

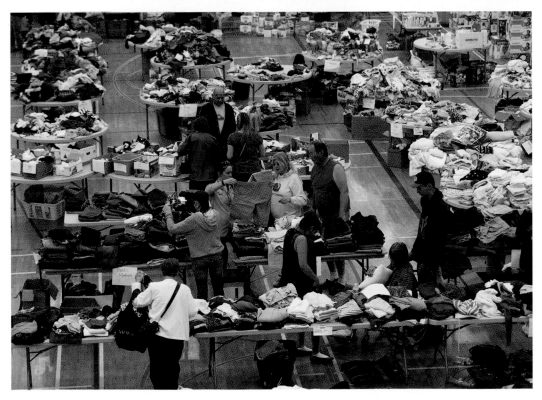

FACING PAGE LEFT Fort McMurray resident Jim Wood rummaged through the remains of his home on June 2, 2016, searching for valuables and family keepsakes.

(Larry Wong/*Edmonton Journal & Sun*)

FACING PAGE RIGHT Many evacuees left with only the clothes on their backs. Here, Melvin Gonyou comforted his thirteen-year-old daughter at a rest stop along the evacuation route.

(Larry Wong/*Edmonton Journal & Sun*)

TOP LEFT Evacuees—shown here at a Lac La Biche evacuation centre—read papers, watched news broadcasts, and monitored websites around the clock for news about their homes. (Ed Kaiser/*Edmonton Journal & Sun*)

BOTTOM LEFT People affected by the fire looked for clothing amongst the thousands of donated pieces at an evacuation centre in Lac La Biche, 290 kilometres south of Fort McMurray.

(Greg Southam/*Edmonton Journal & Sun*)

ABOVE A sign of support for evacuees was displayed on this farm near Colinton, Alberta, 360 kilometres southwest of Fort McMurray, along the route that many evacuees took while fleeing the massive fire.

(Ian Kucerak/*Edmonton Journal & Sun*)

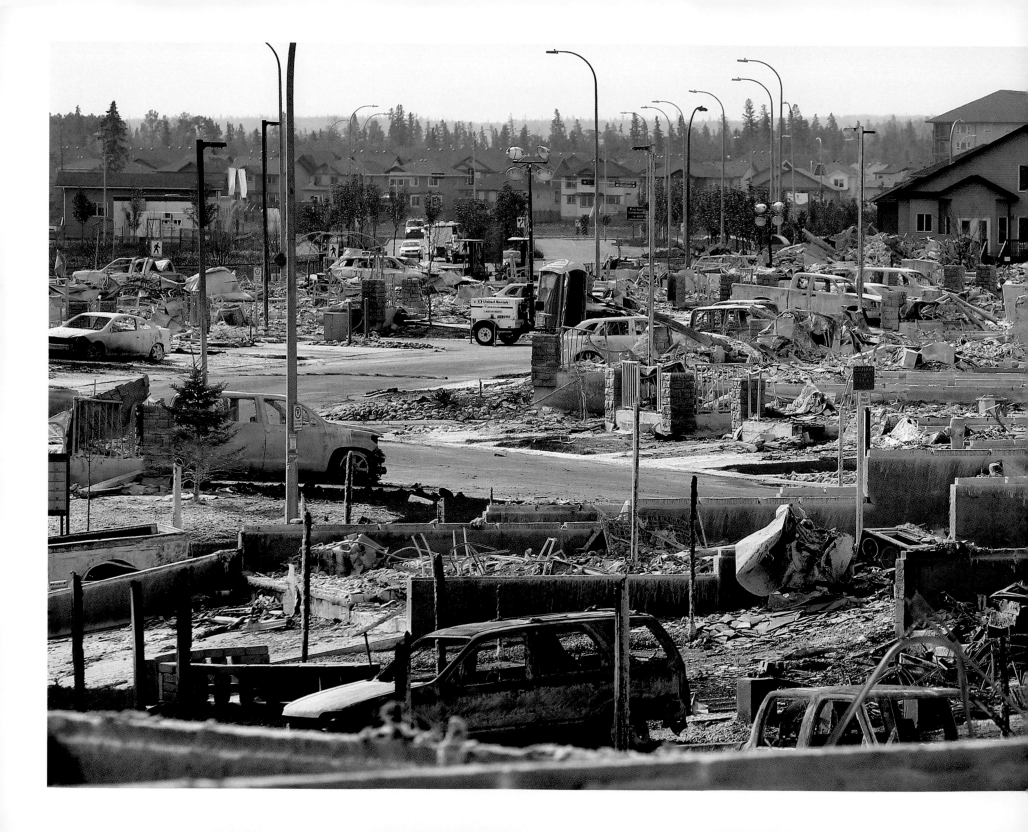

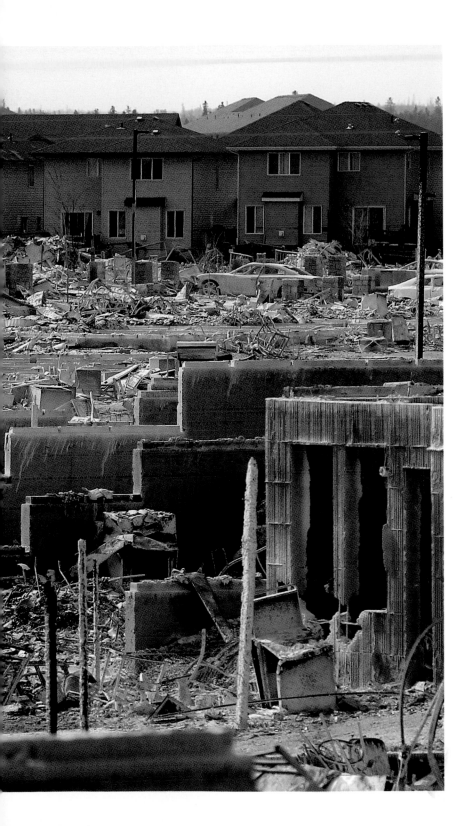

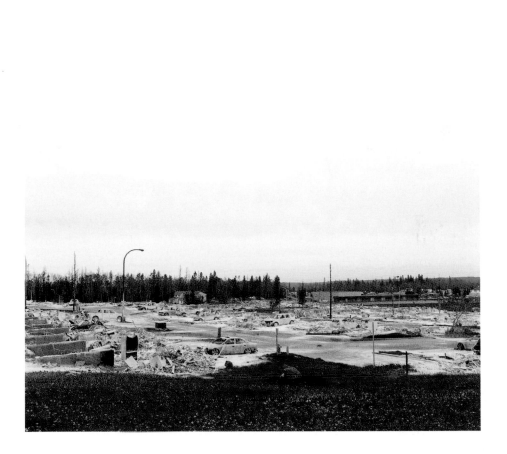

LEFT The Timberlea area was another Fort McMurray neighbourhood devastated by the 2016 blaze.

(Larry Wong/*Edmonton Journal & Sun*)

ABOVE Damage caused by the wildfire to the Fort McMurray neighbourhood of Abasand is seen here one month after the fire.

(Ian Kucerak/*Edmonton Journal & Sun*)

DOCUMENTING THE PRAIRIES

POSTMEDIA'S NEWSPAPERS have been publishing on the Prairies since the late 1800s. The *Regina Leader-Post* and *Calgary Herald* began publishing in 1883, followed by the *Saskatoon StarPhoenix* in 1902 and the *Edmonton Journal* in 1903. In 2014, Postmedia announced the acquisition of Sun Media's English language news organizations, including the *Calgary Sun*, *Edmonton Sun*, and *Winnipeg Sun*. Journalists from these seven news organizations contributed to *Wild Weather on the Prairies*. Together, these organizations work to reflect the stories and spirit of the Prairies on a daily basis.